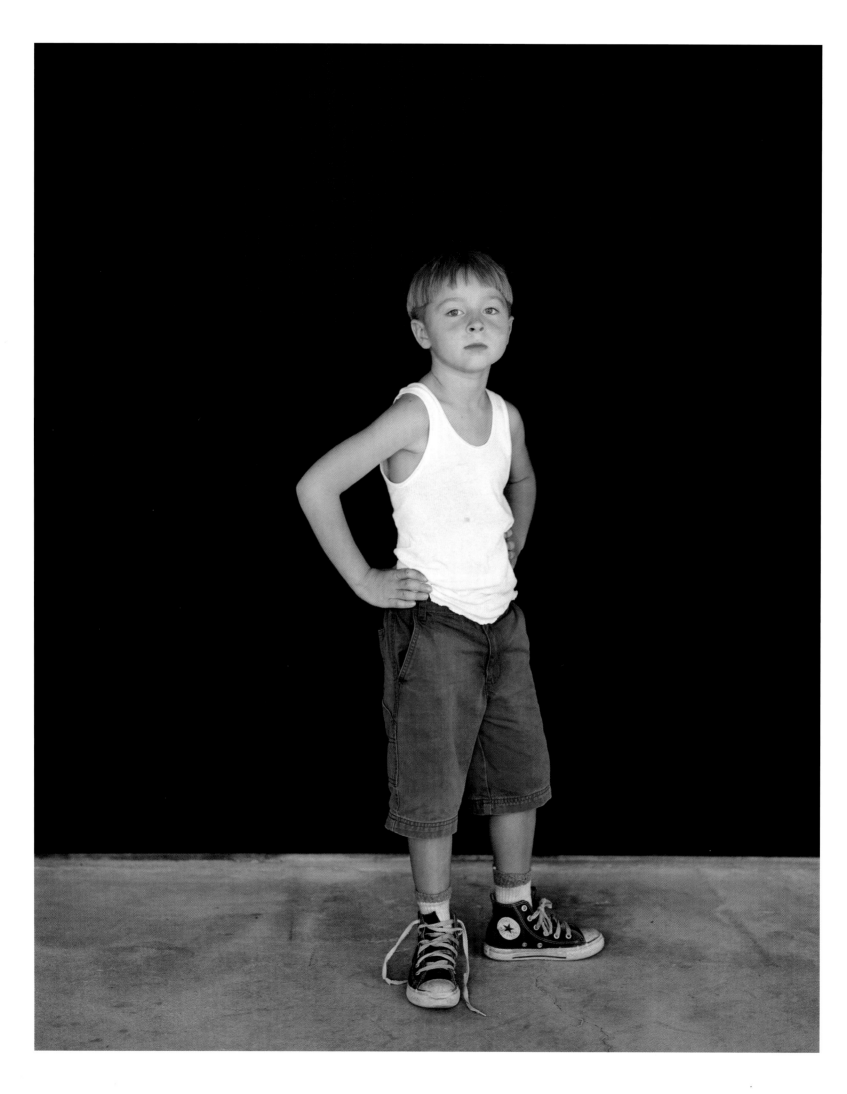

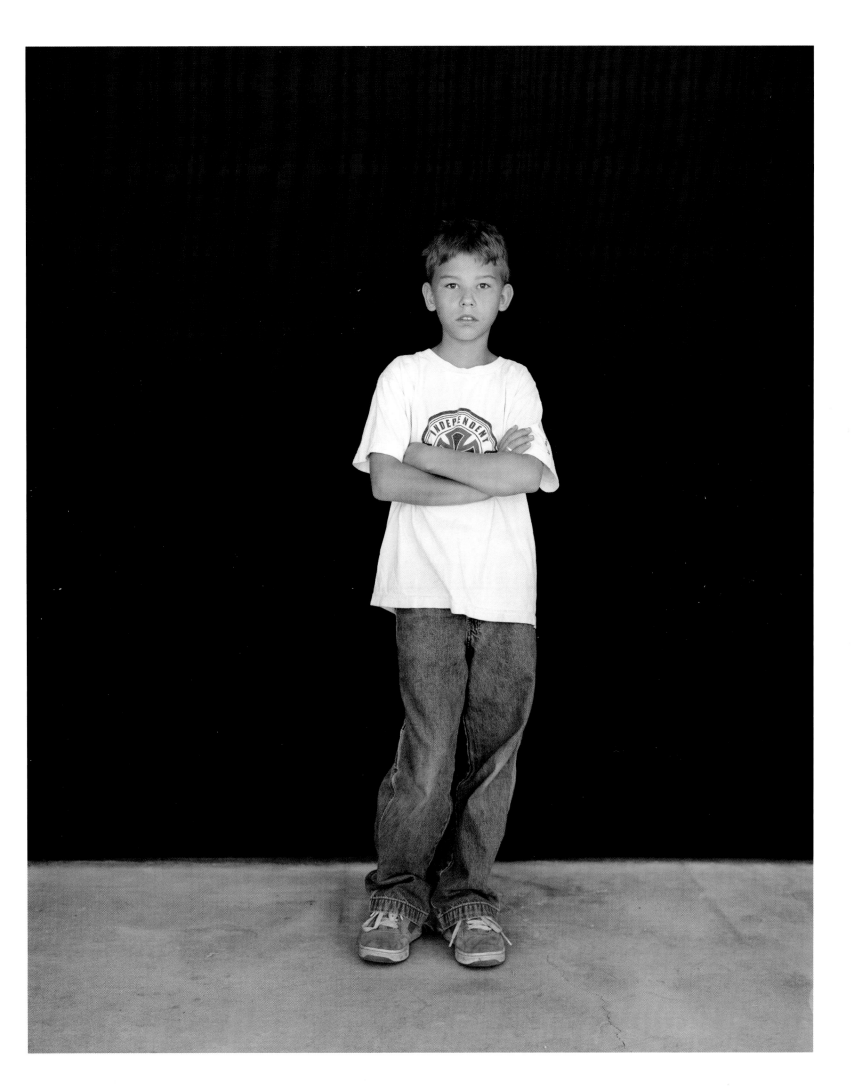

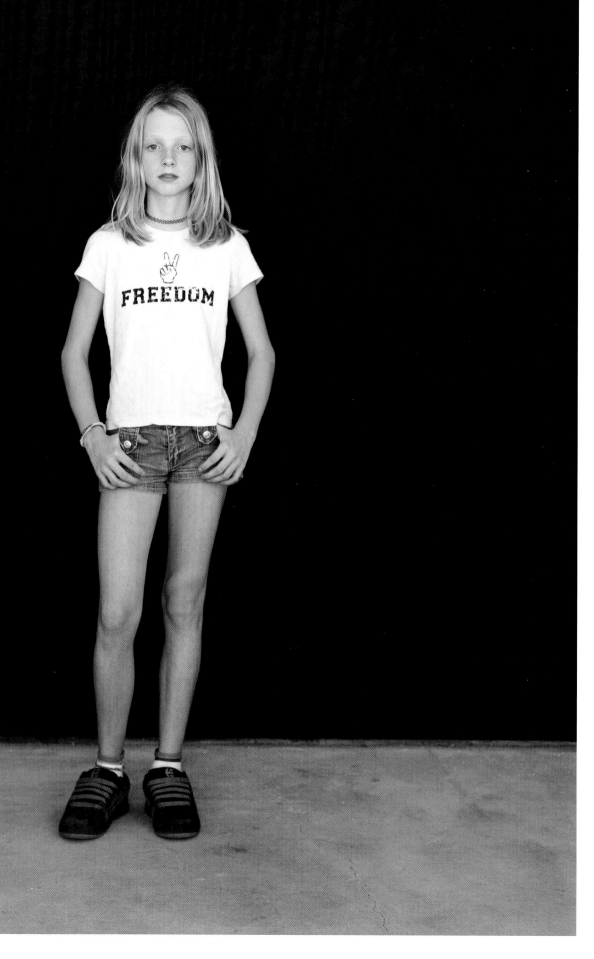

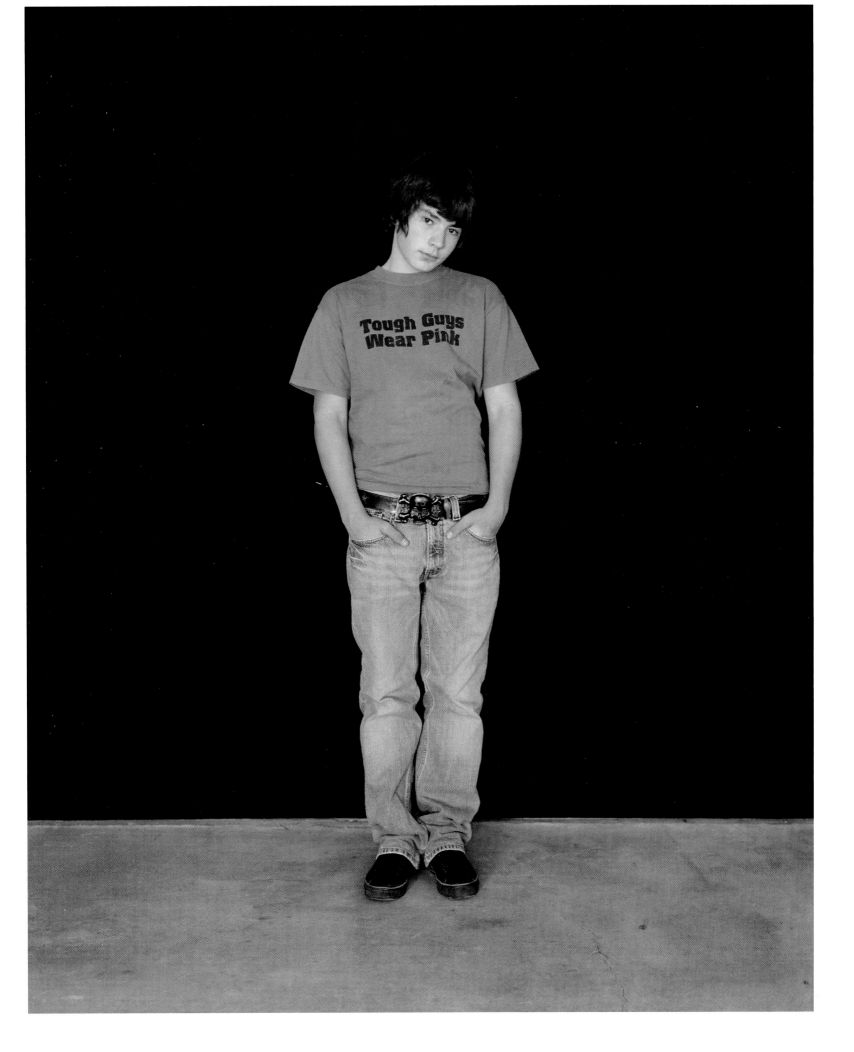

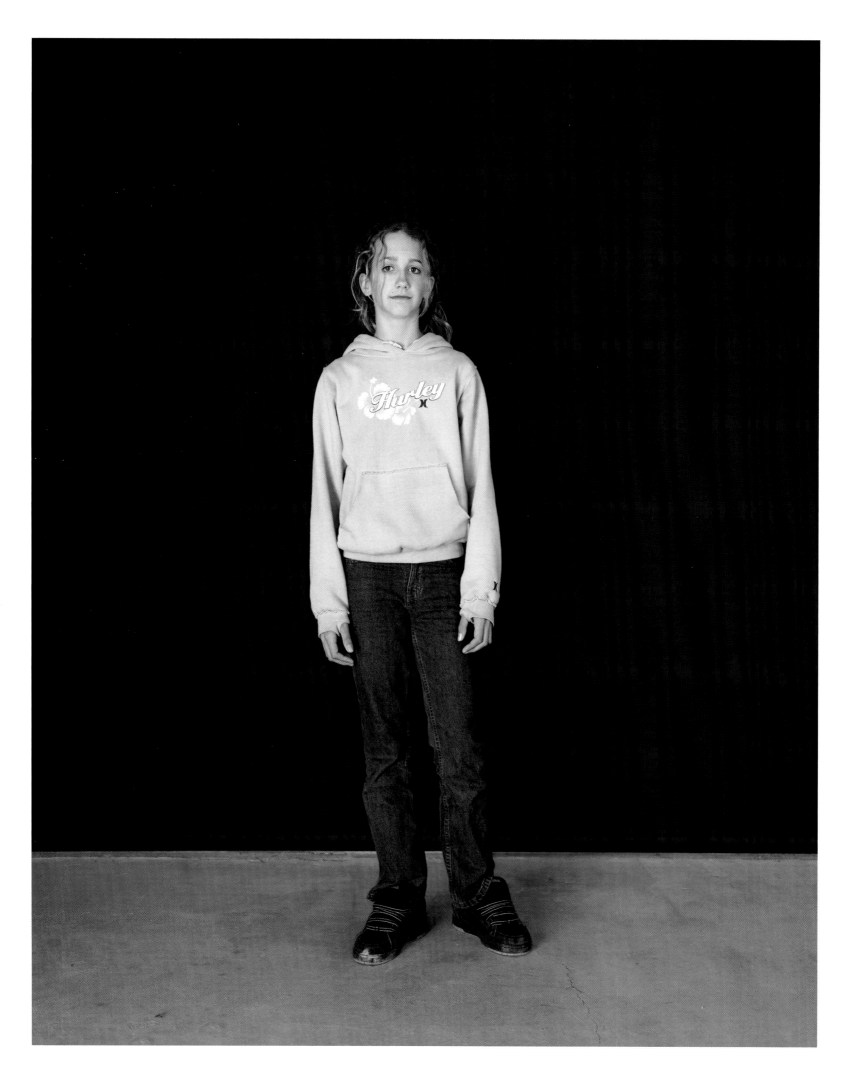

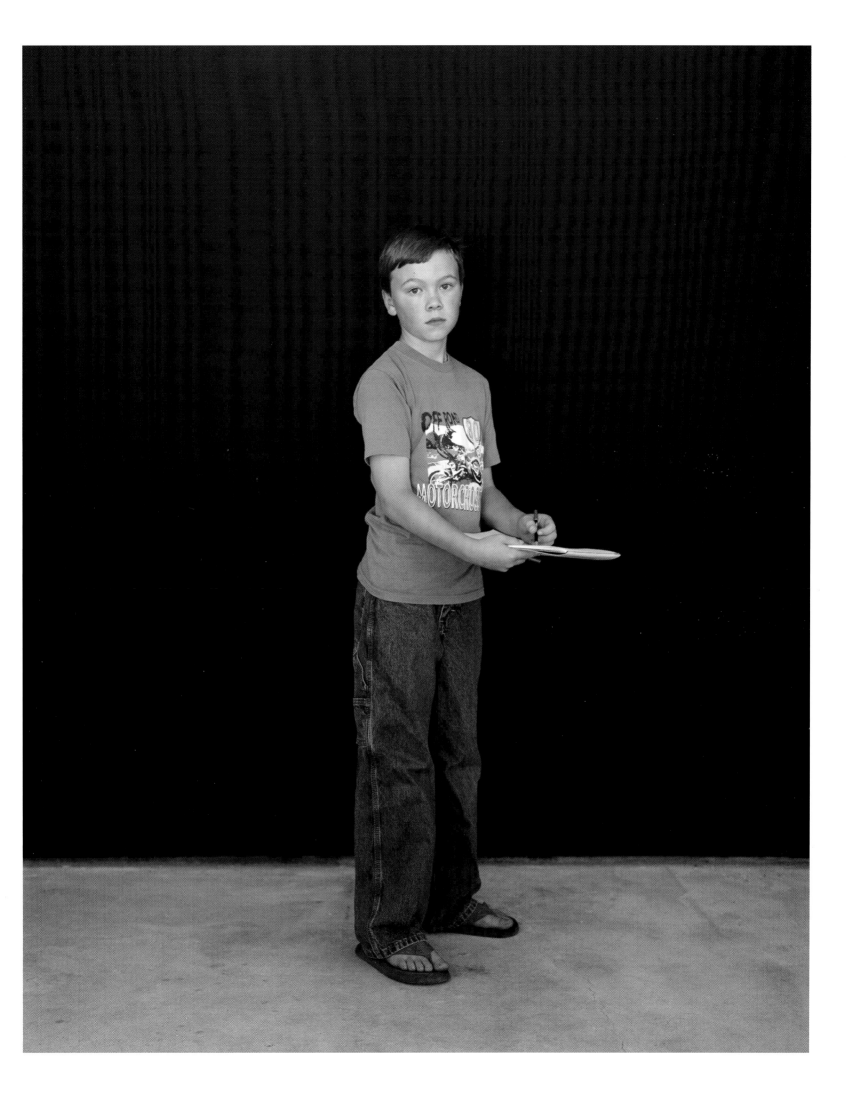

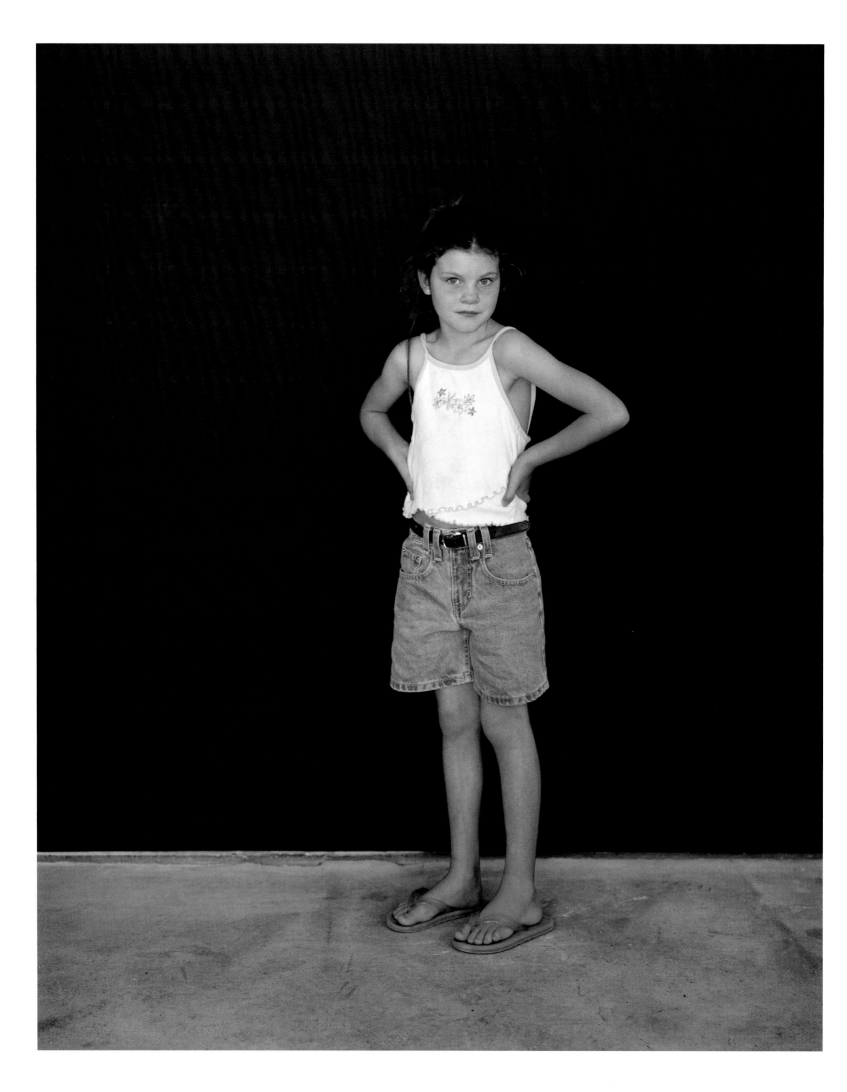

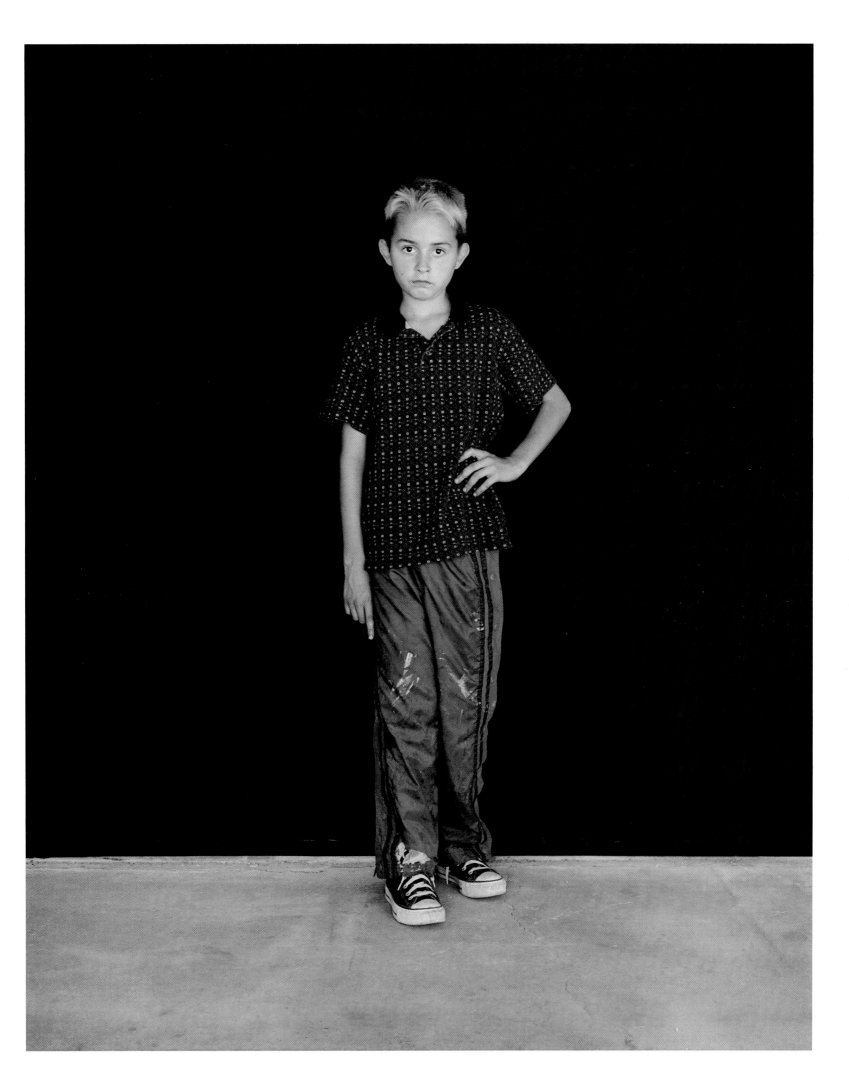

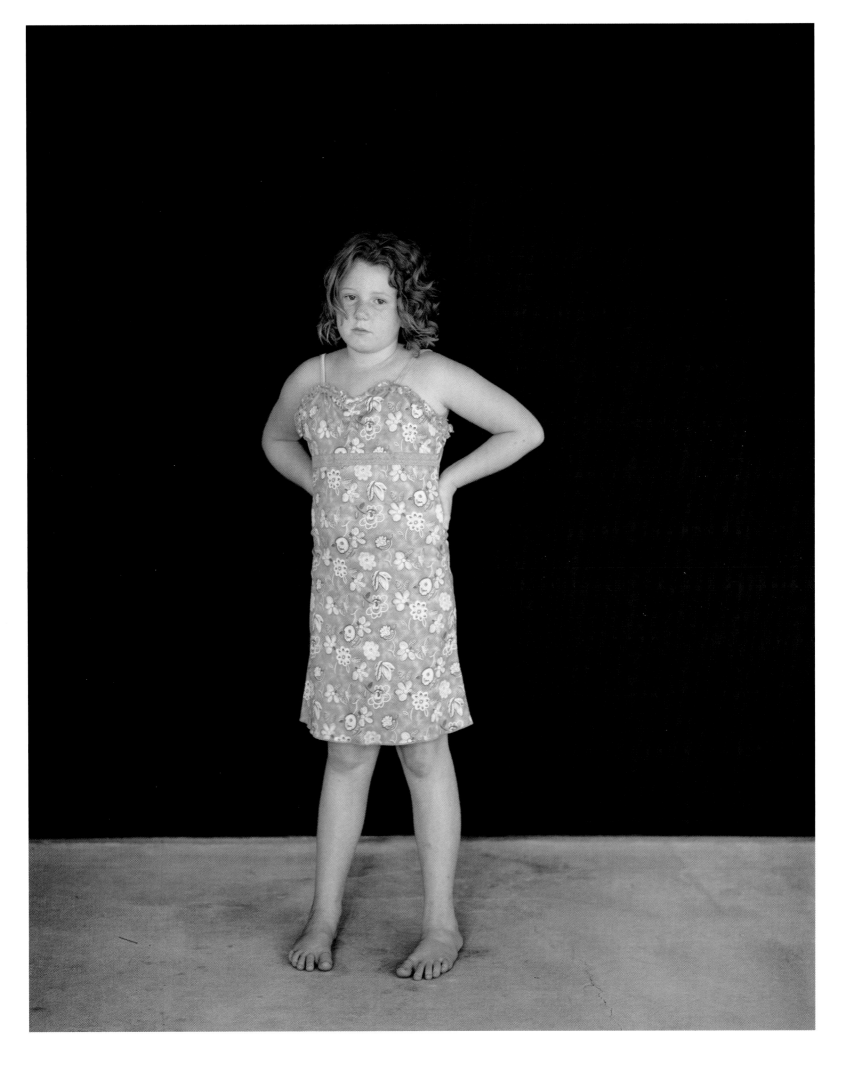

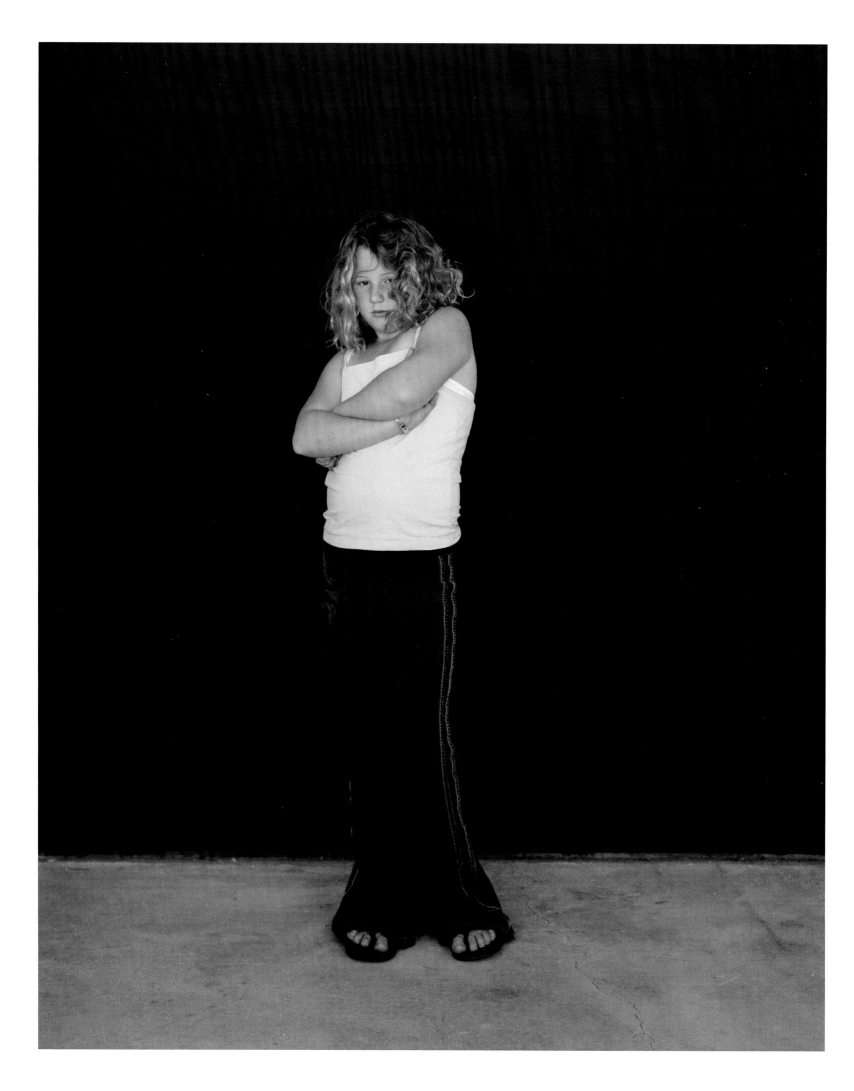

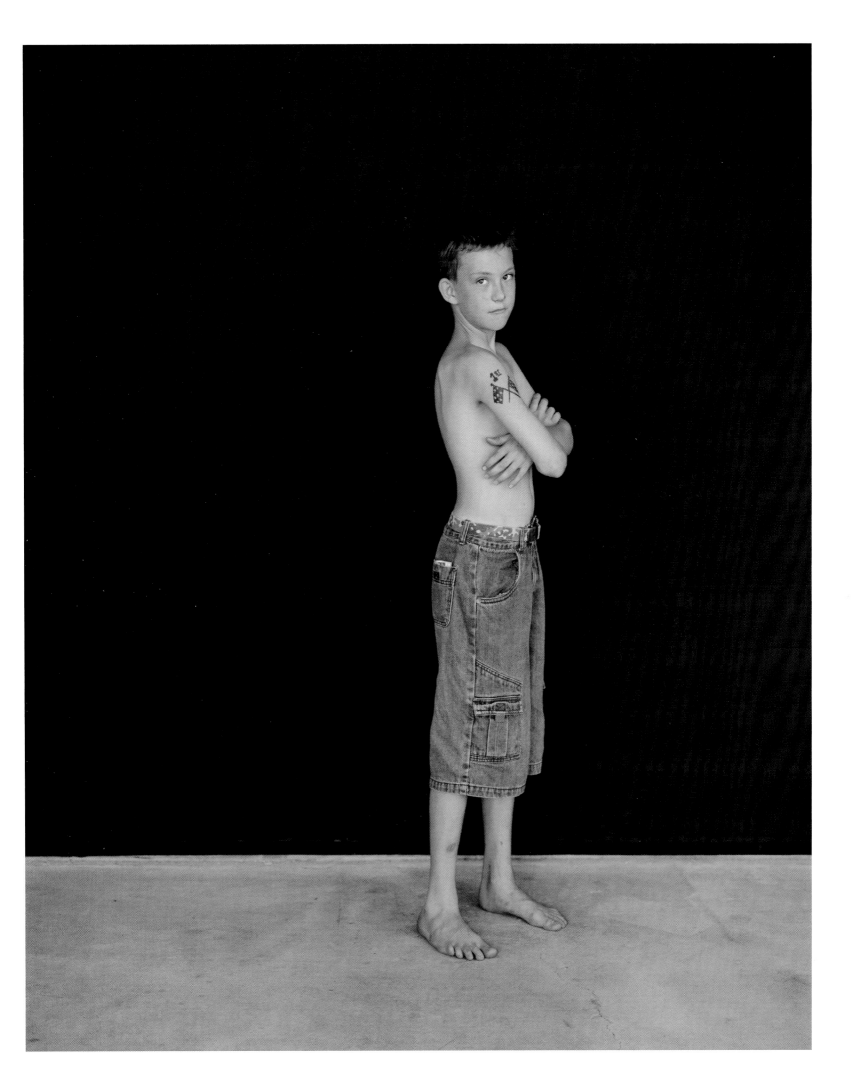

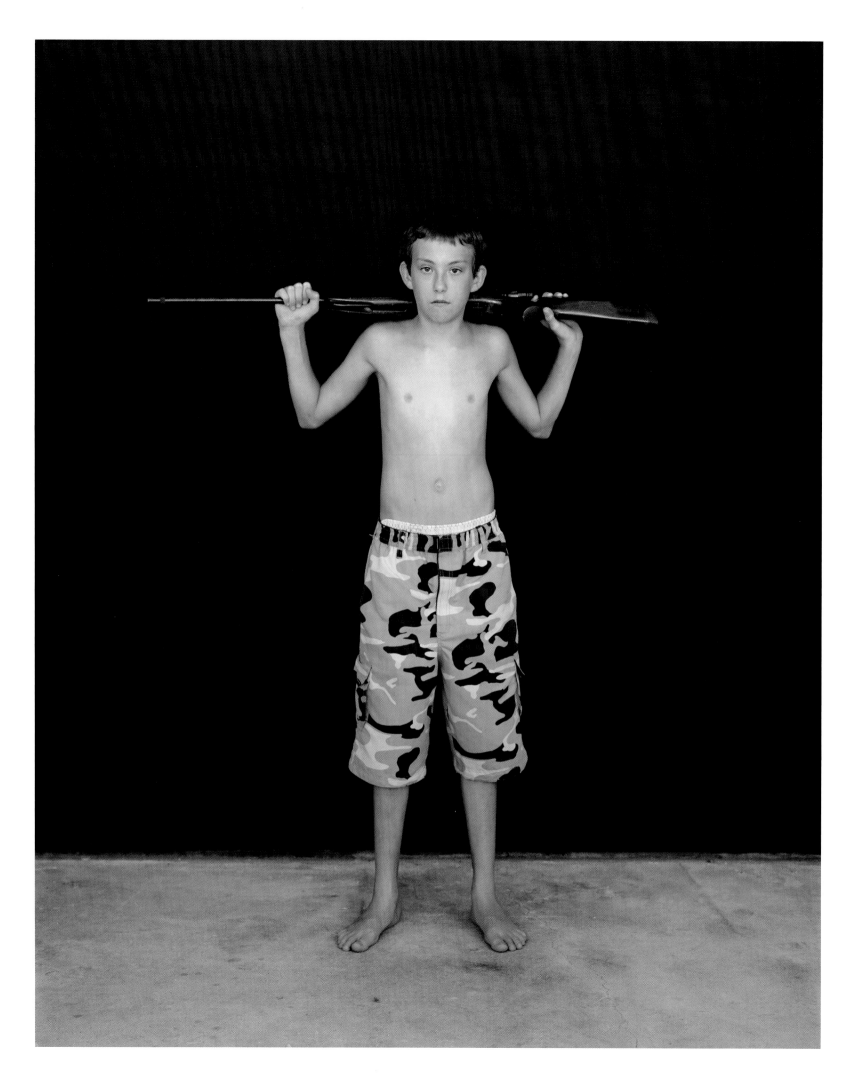

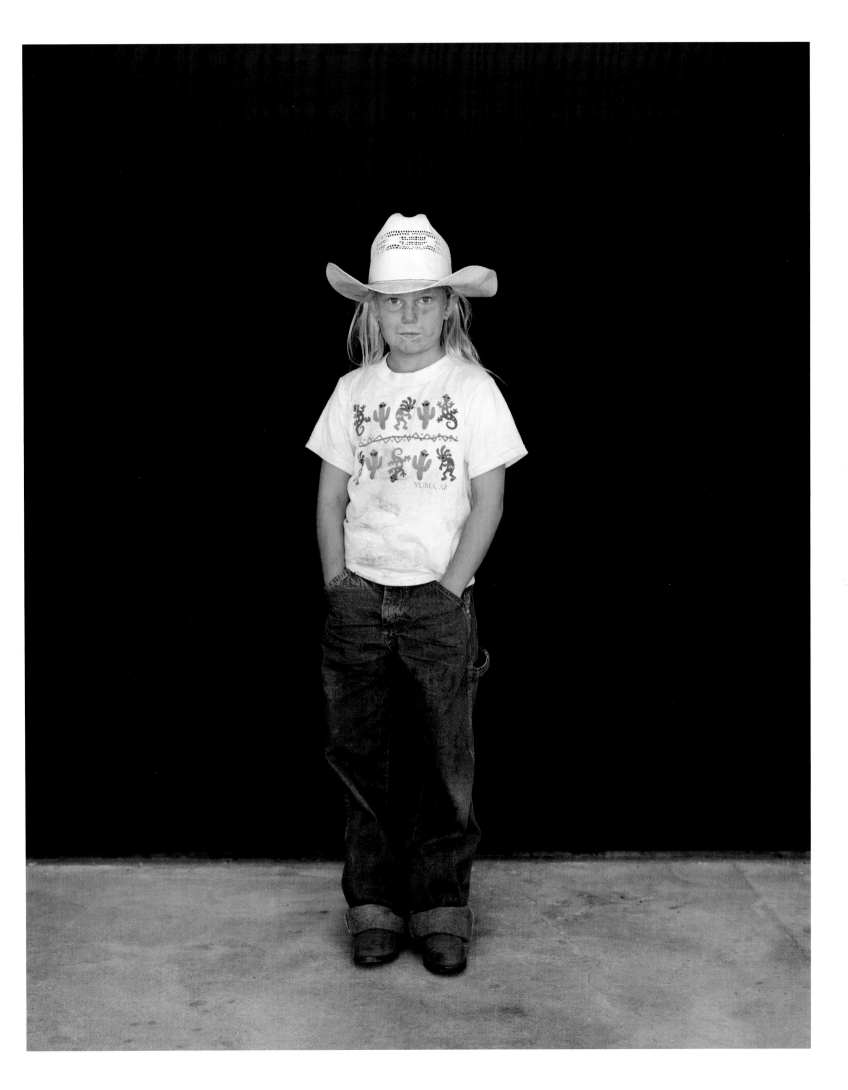

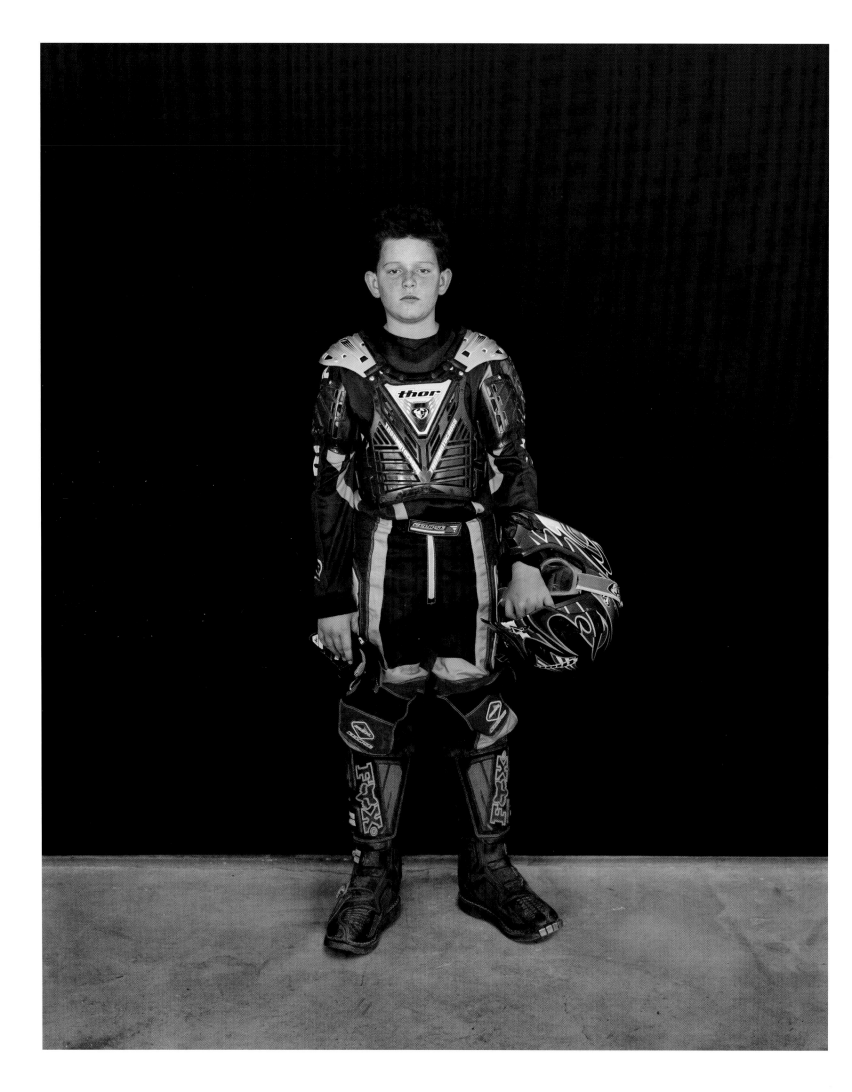

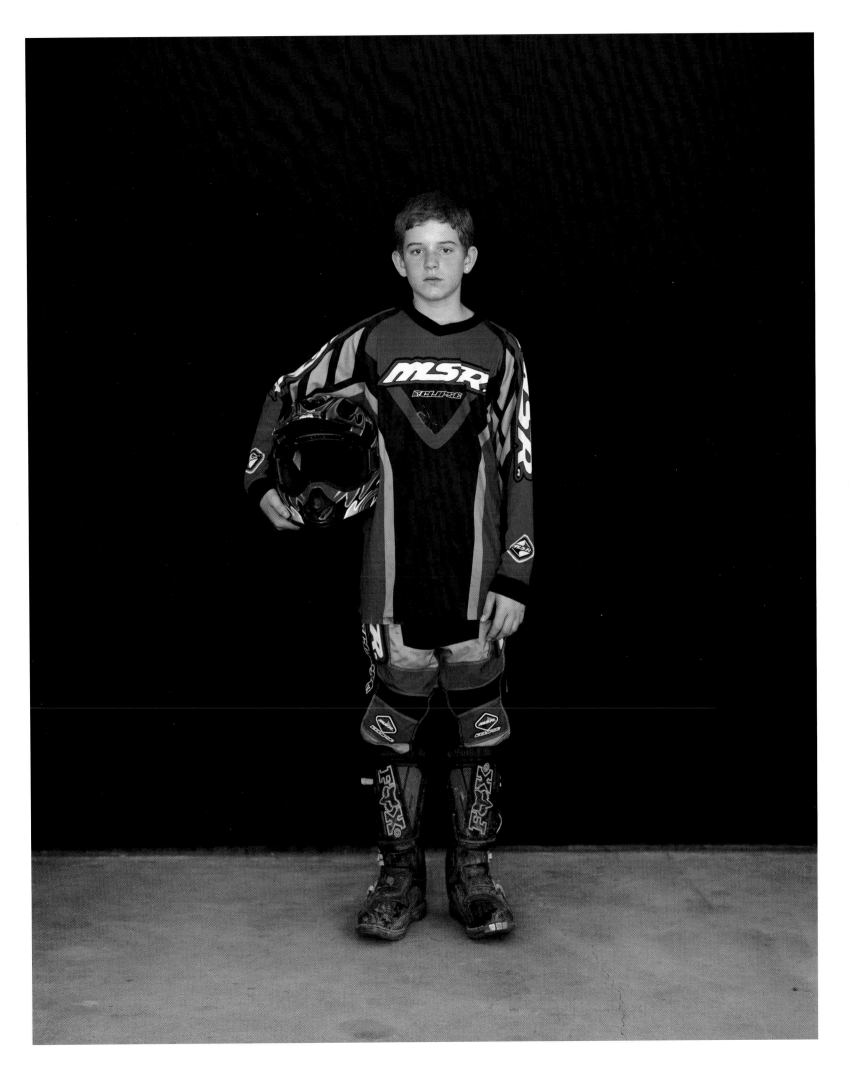

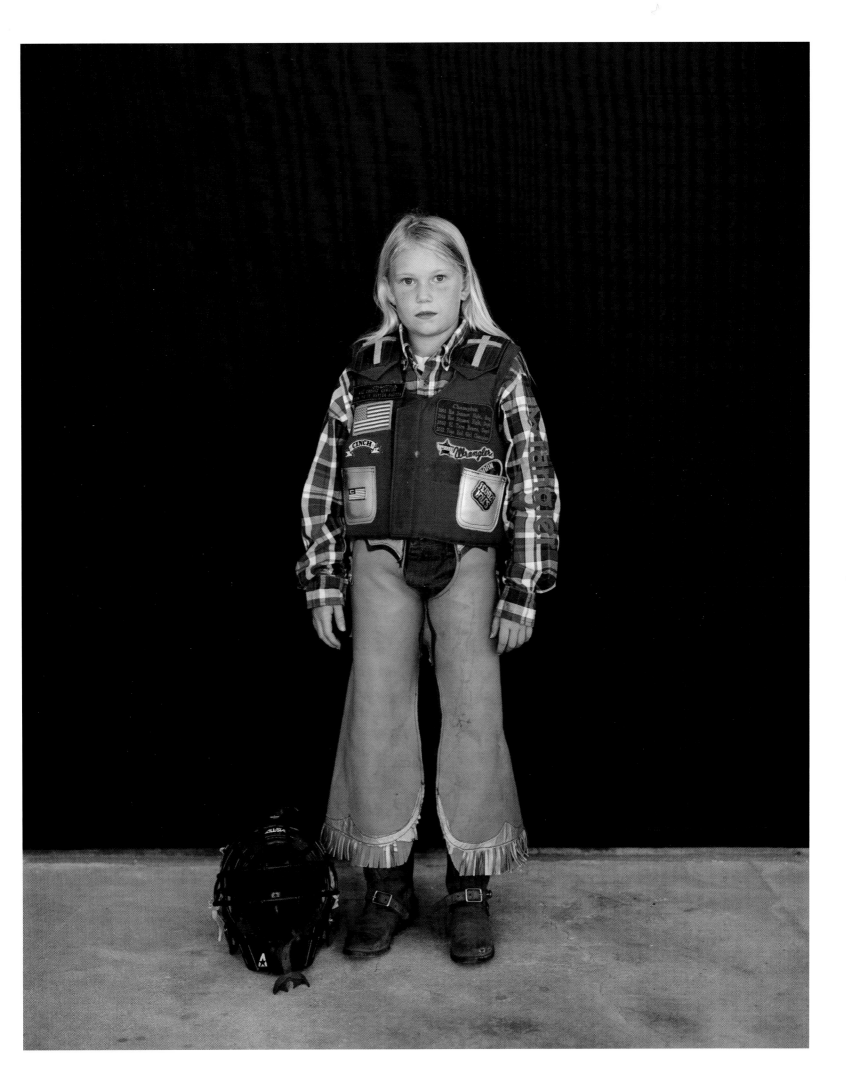

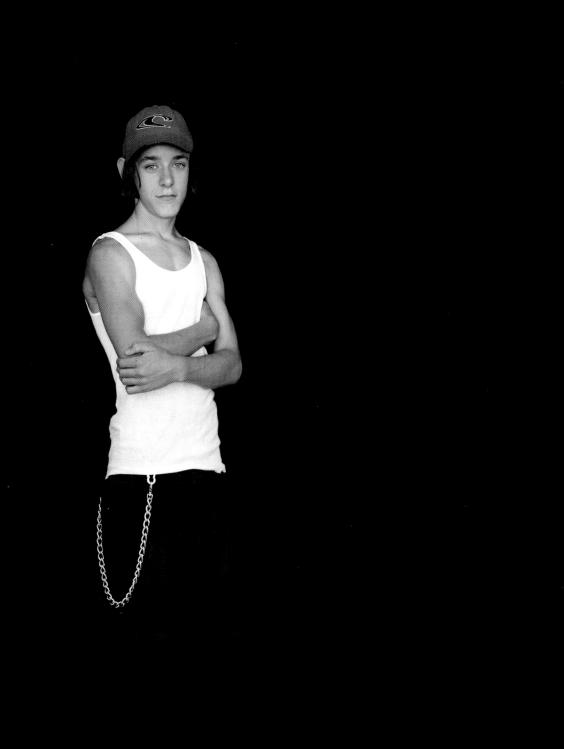

PINE

FLAT

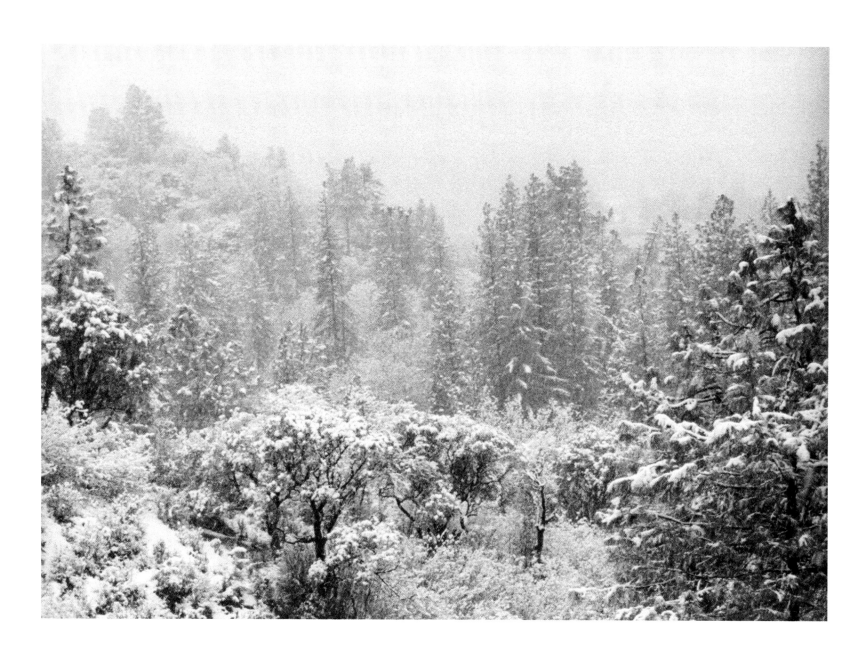

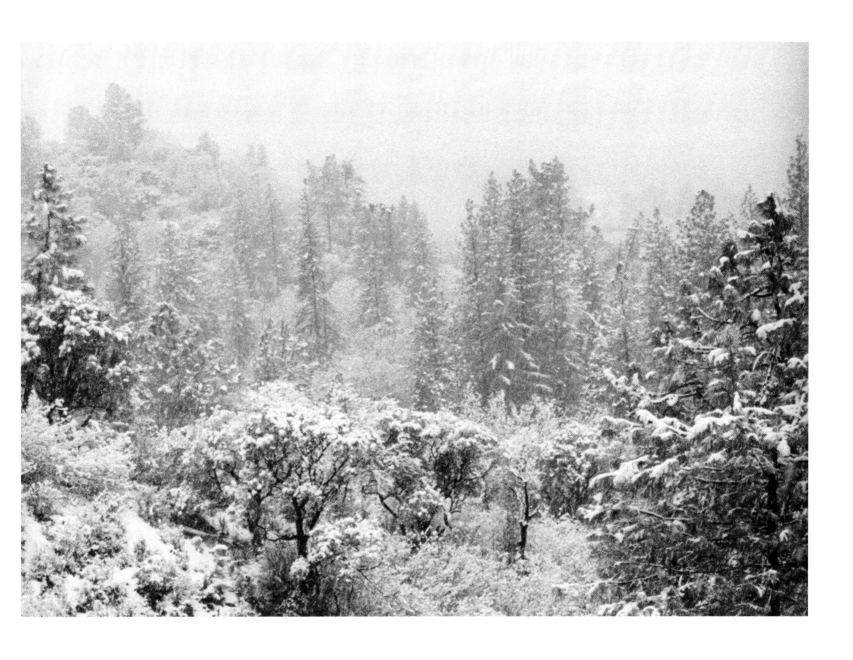

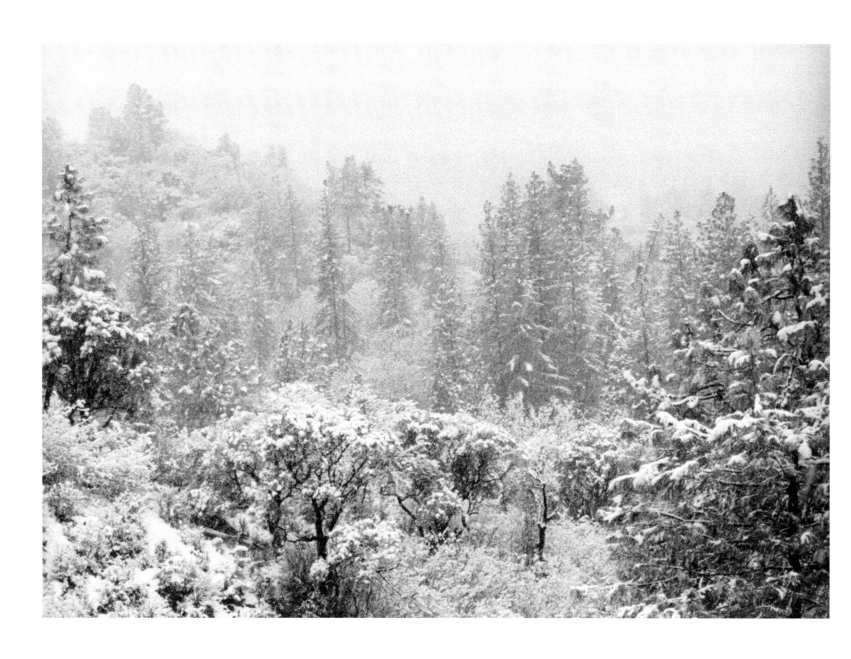

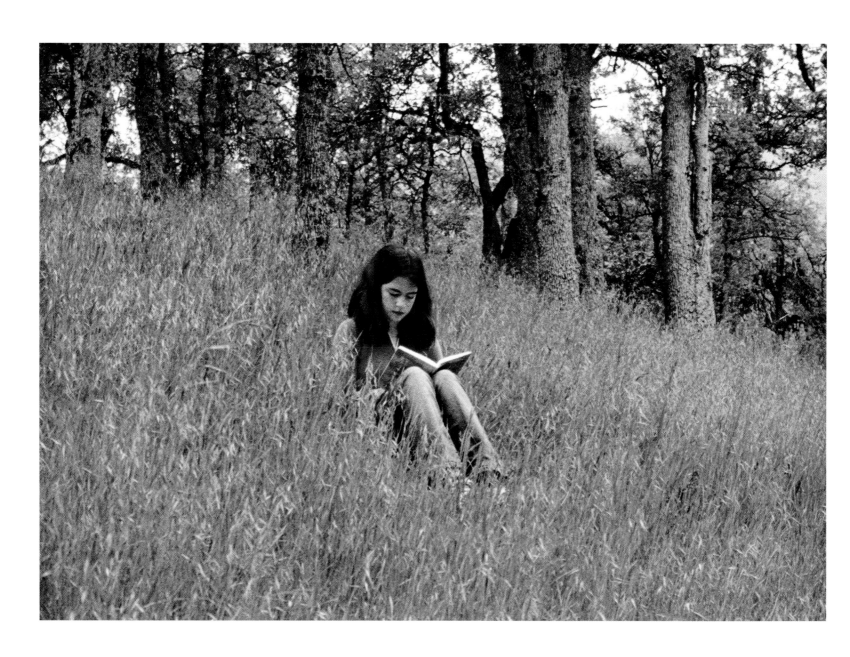

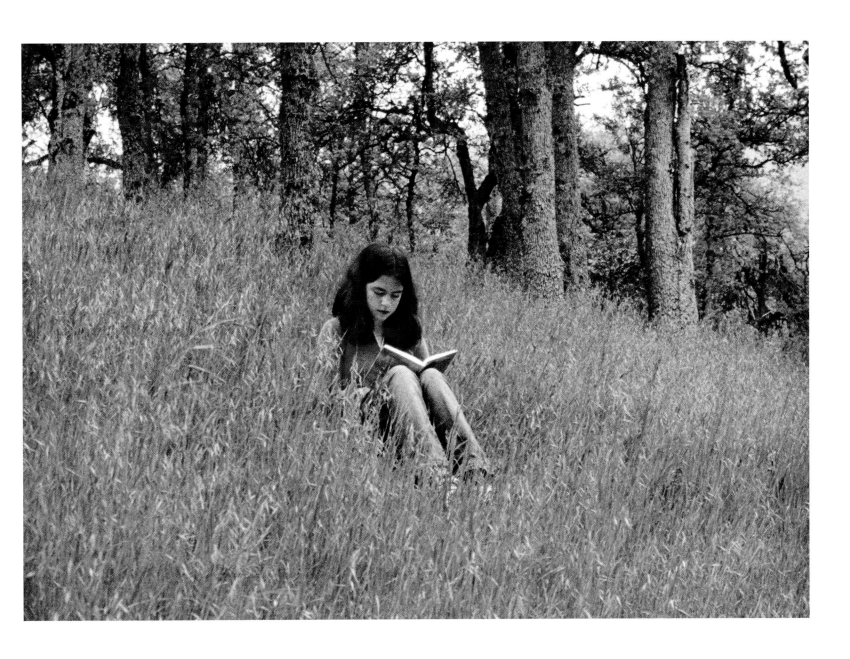

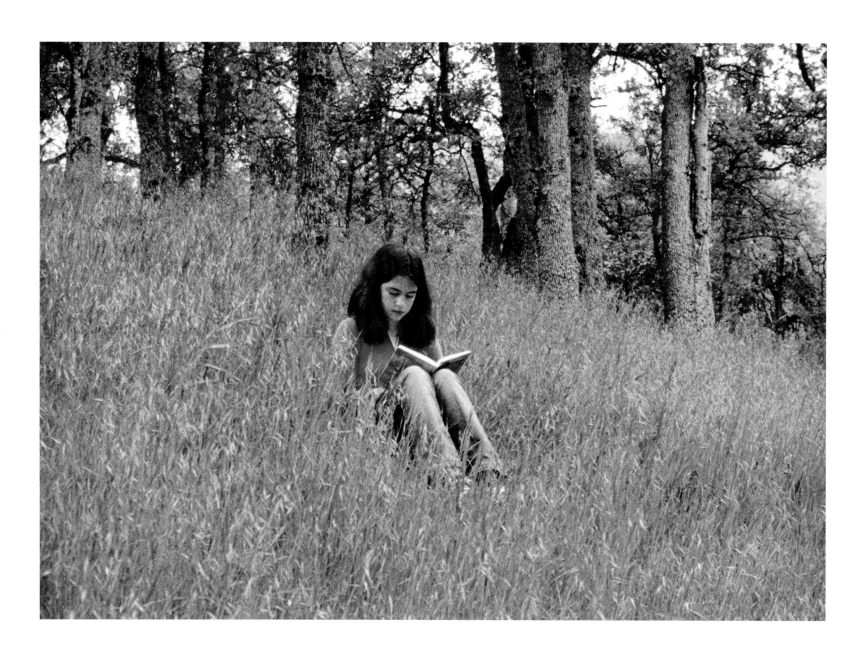

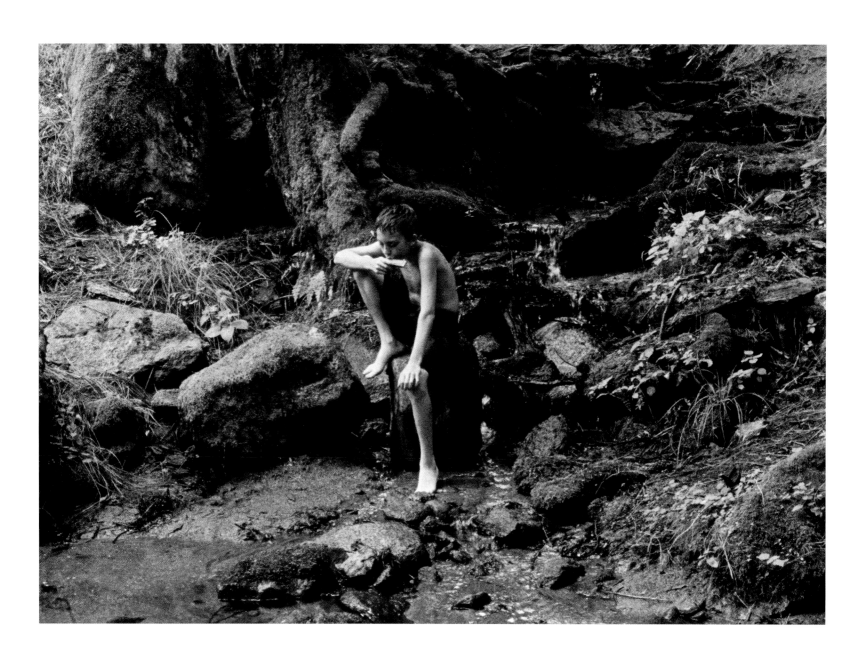

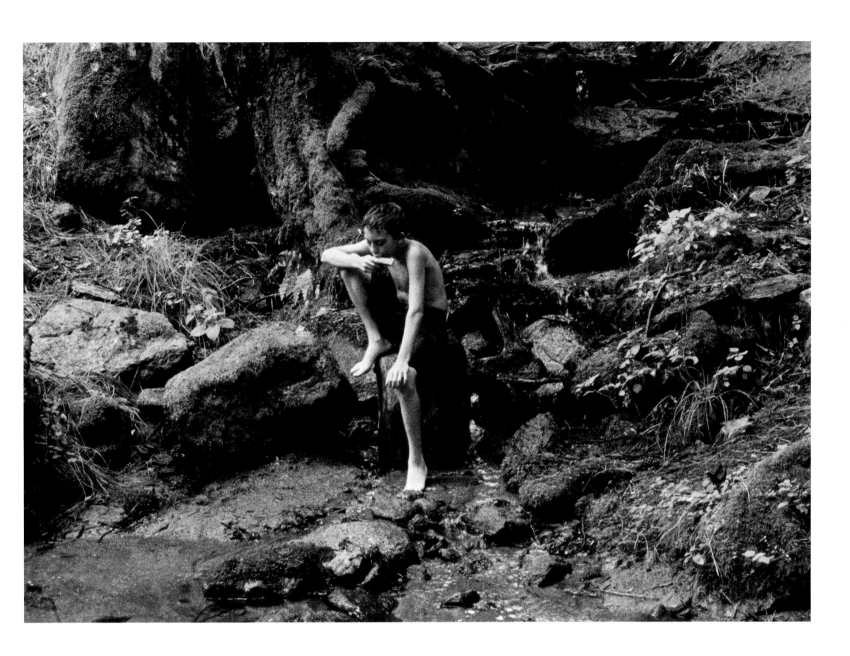

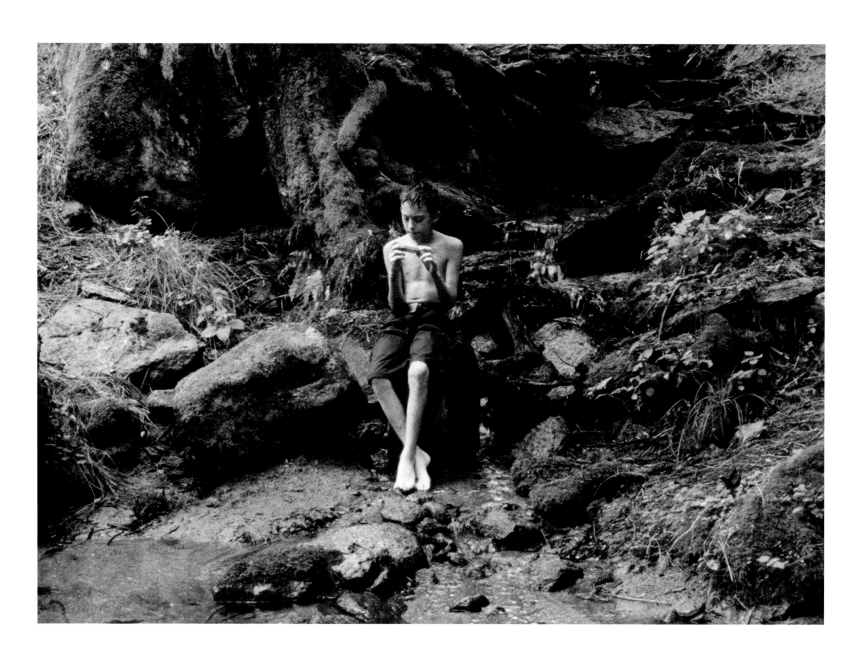

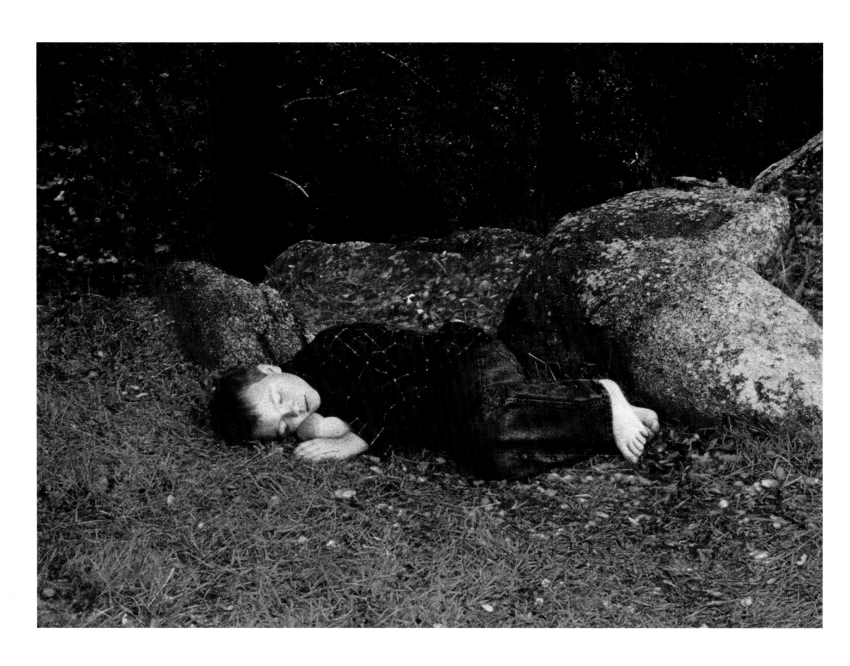

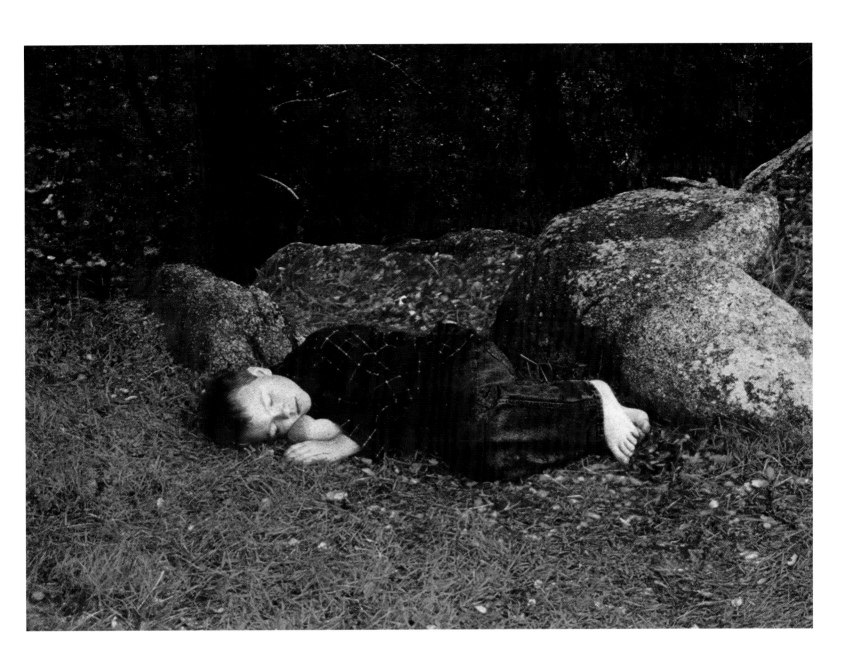

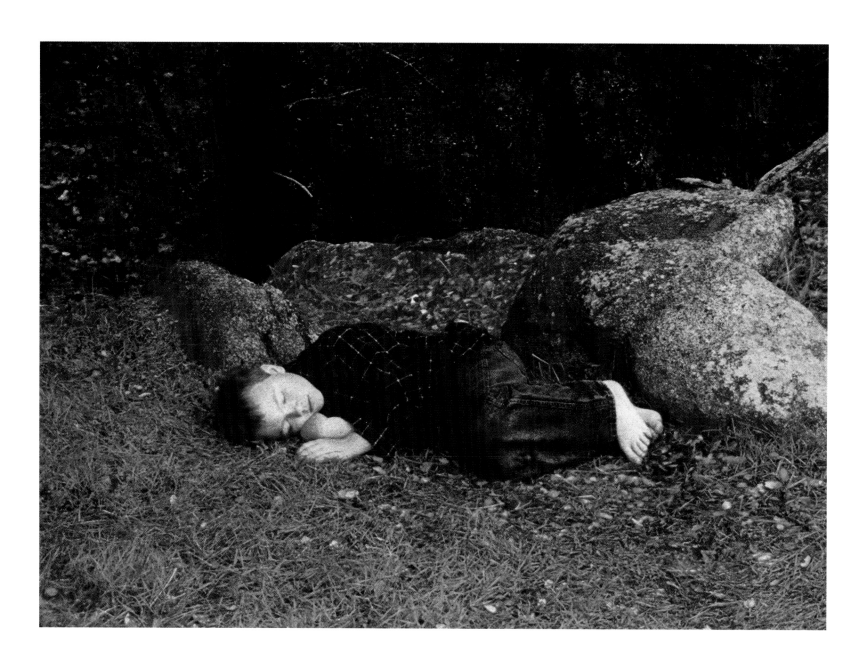

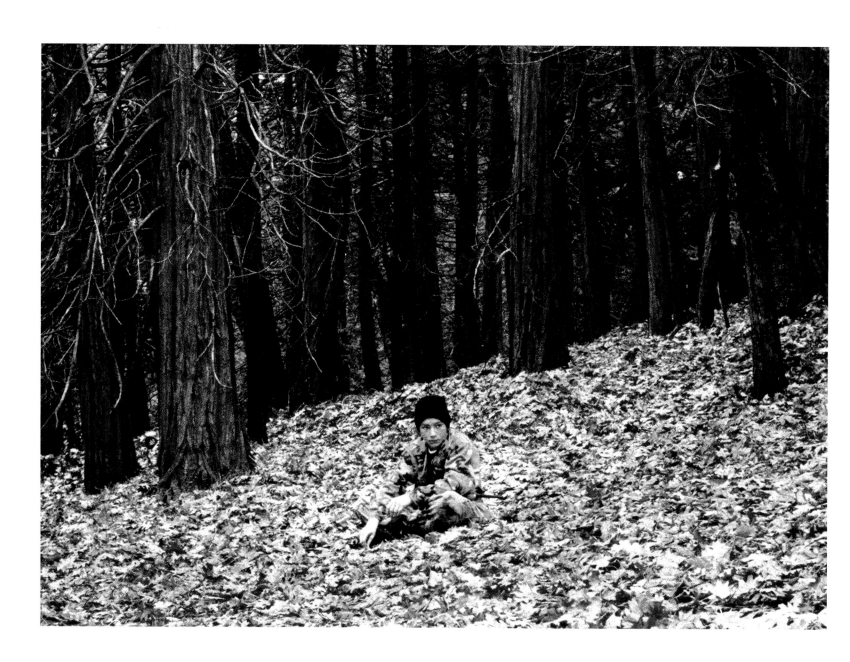

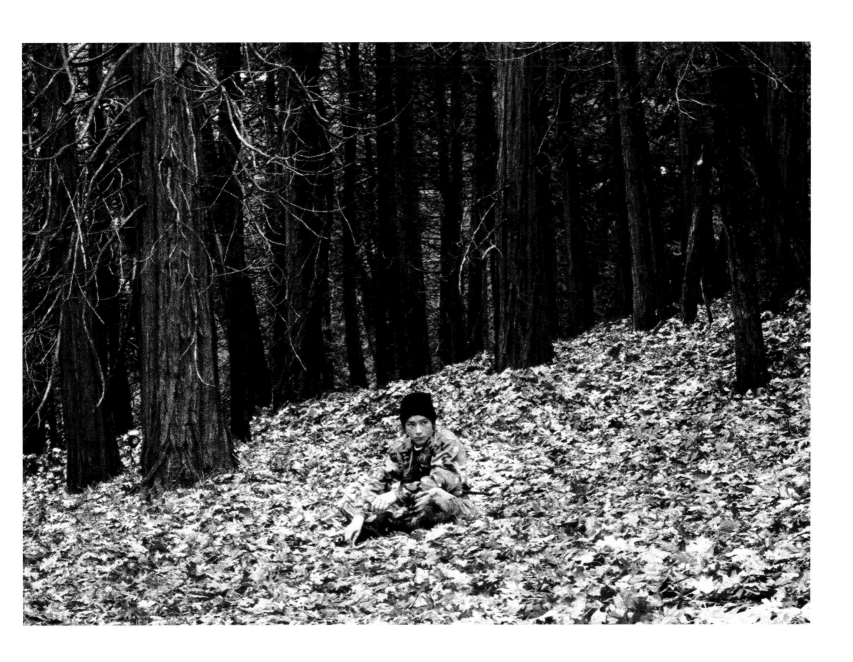

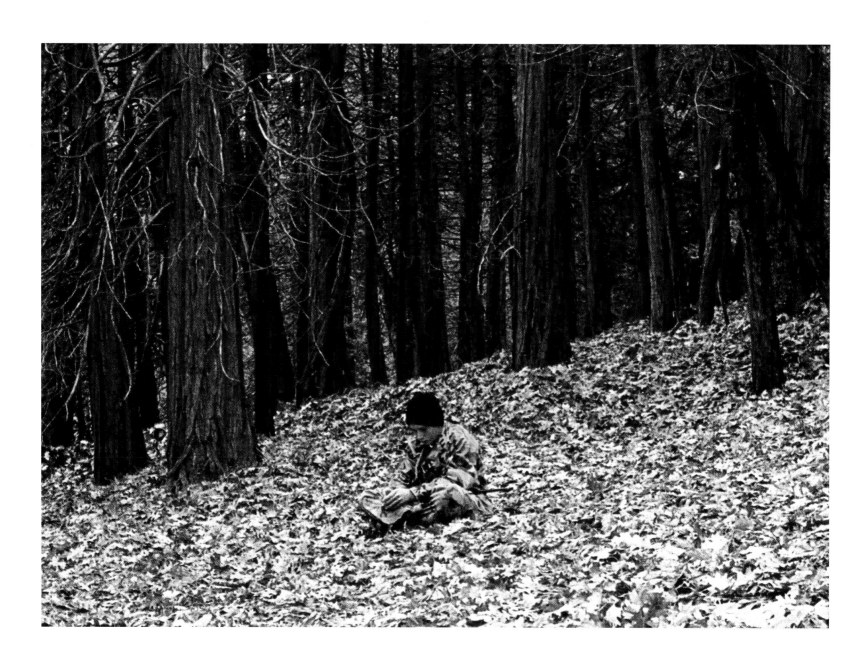

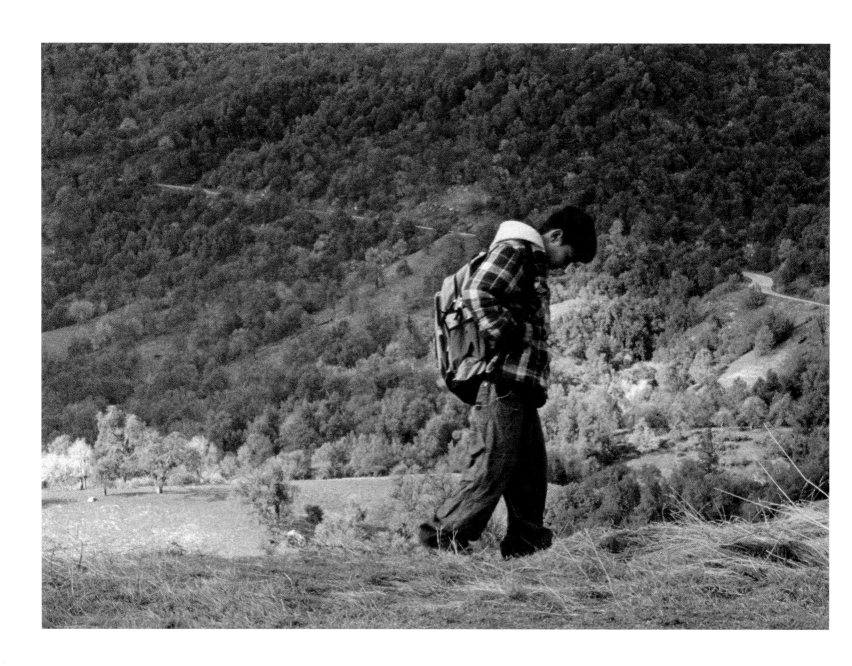

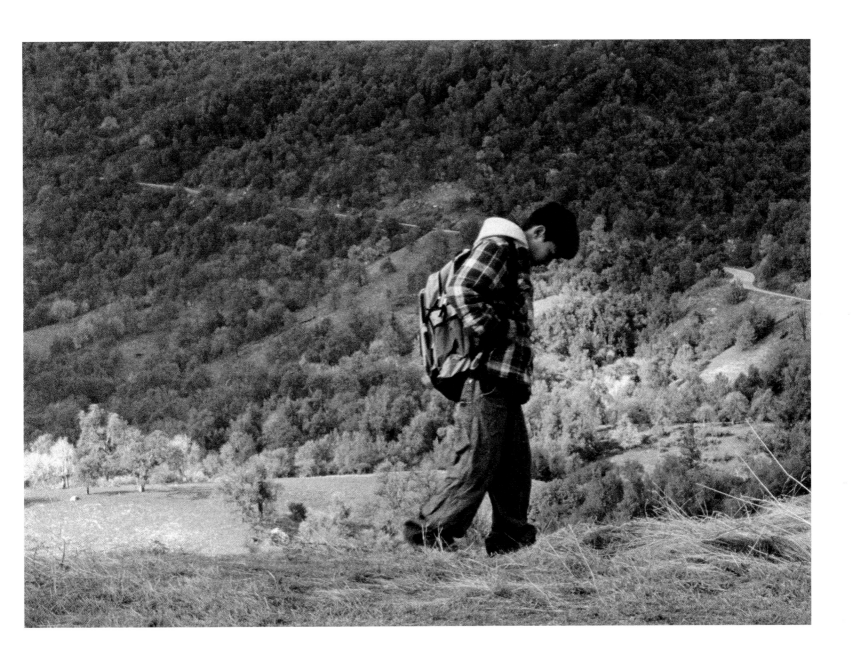

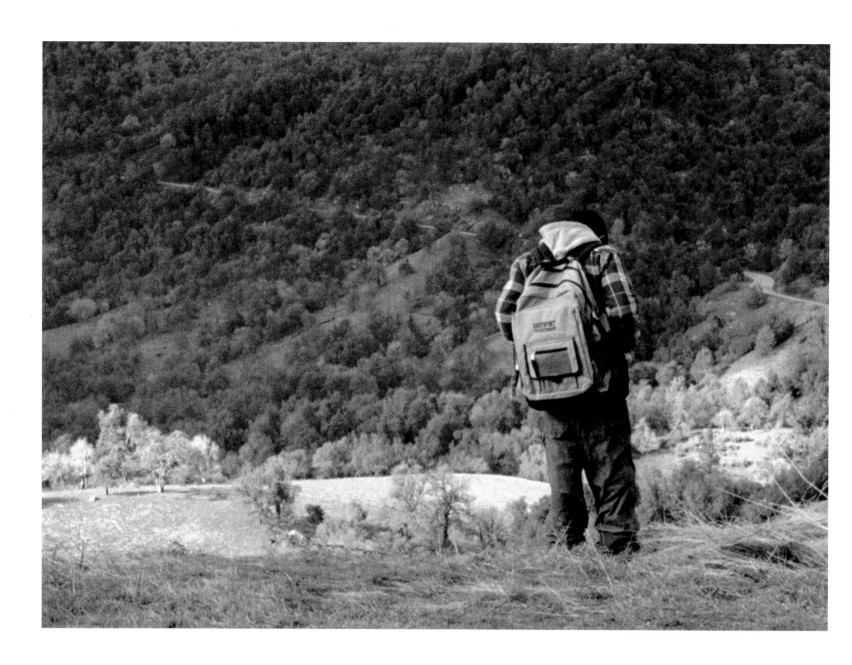

INTERM

MISSION

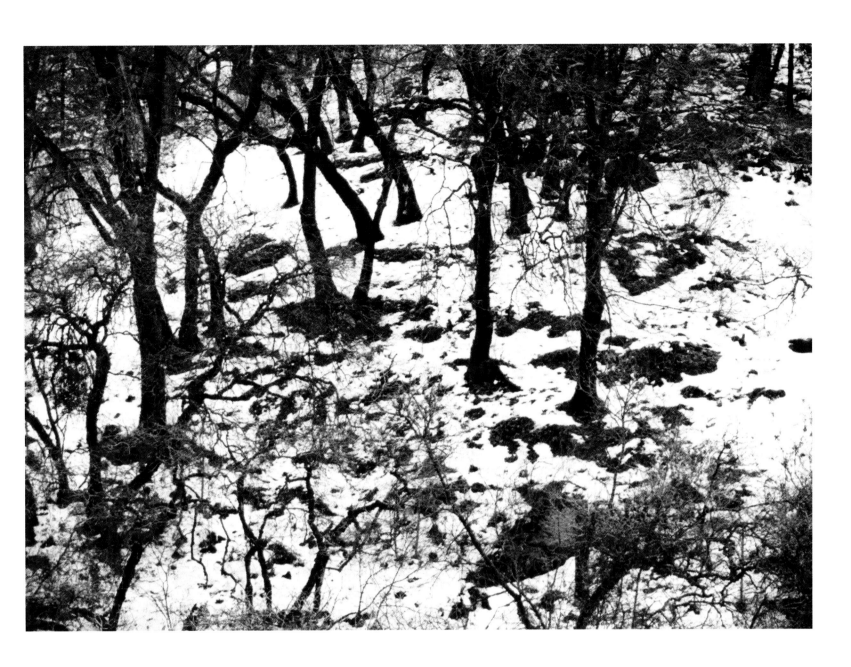

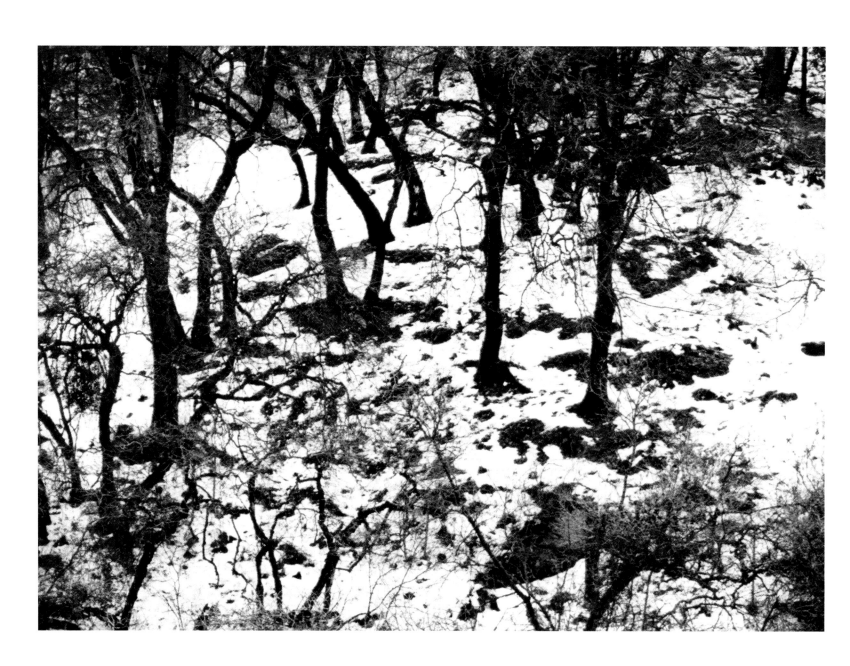

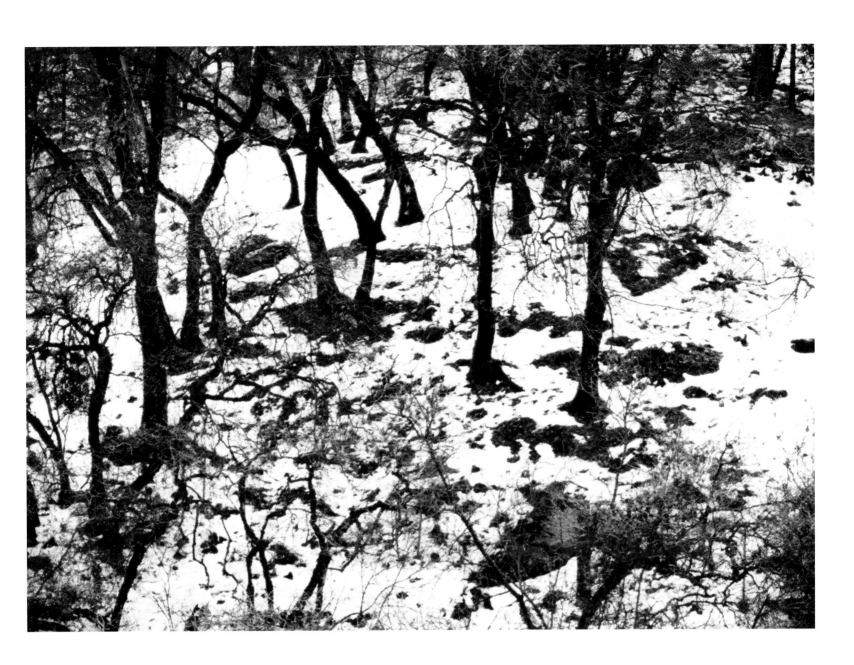

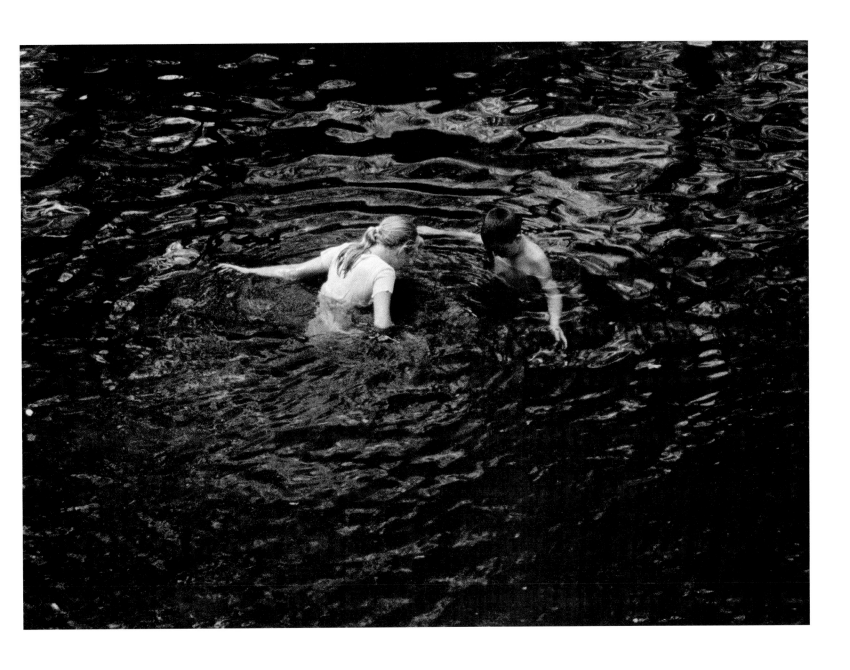

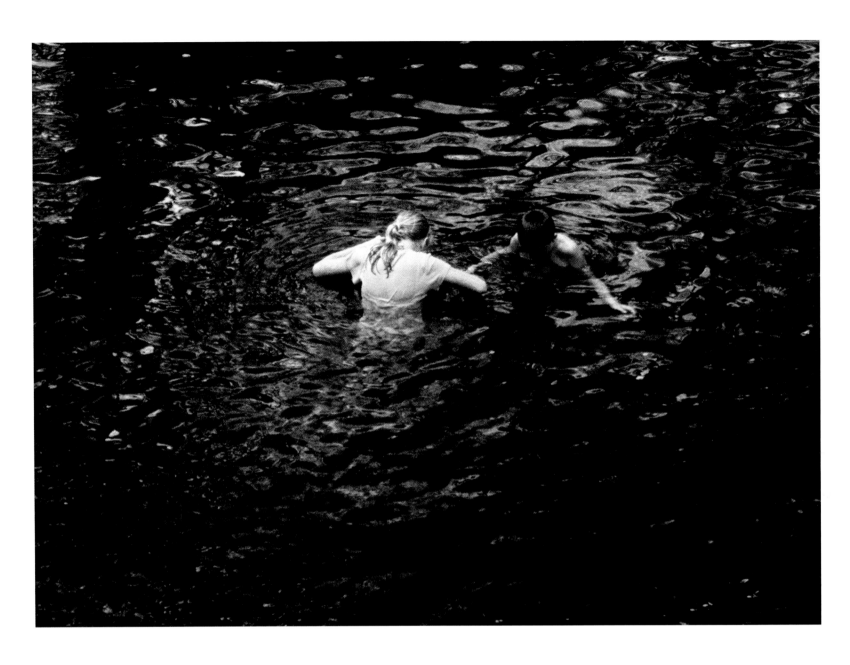

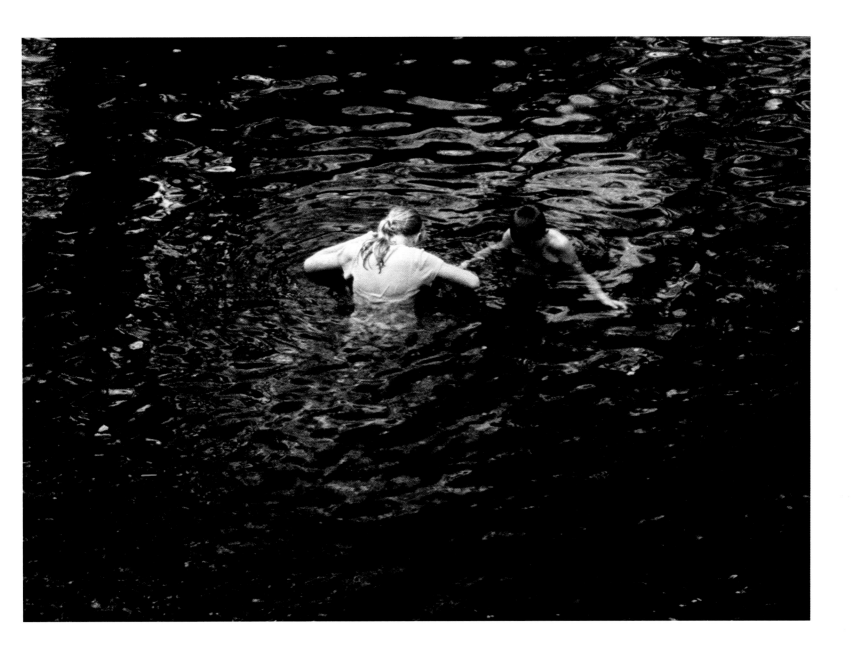

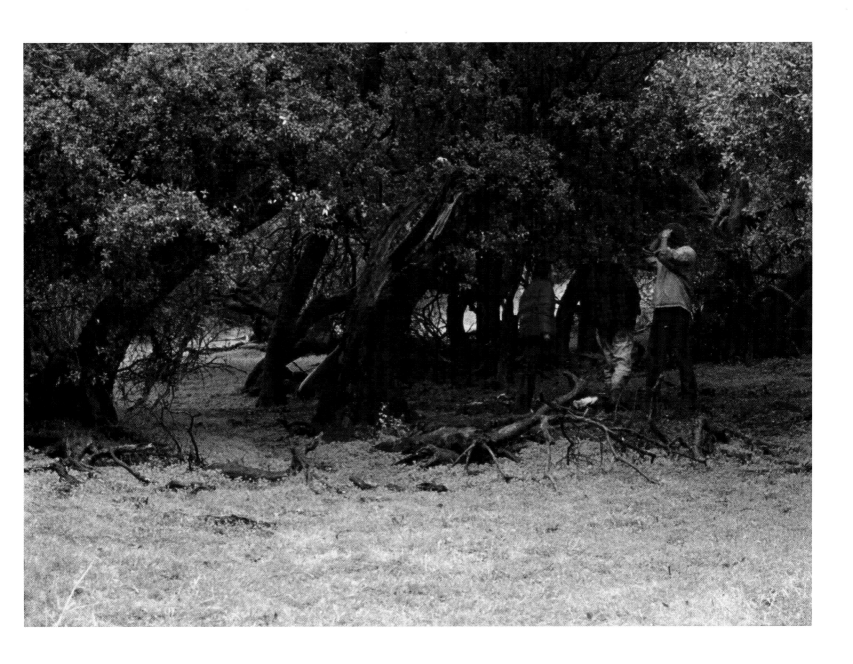

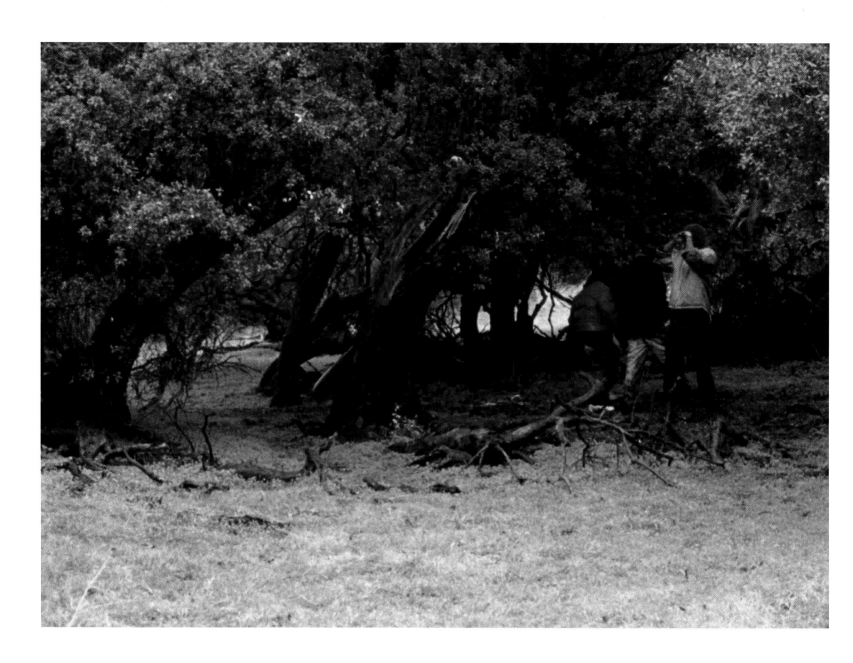

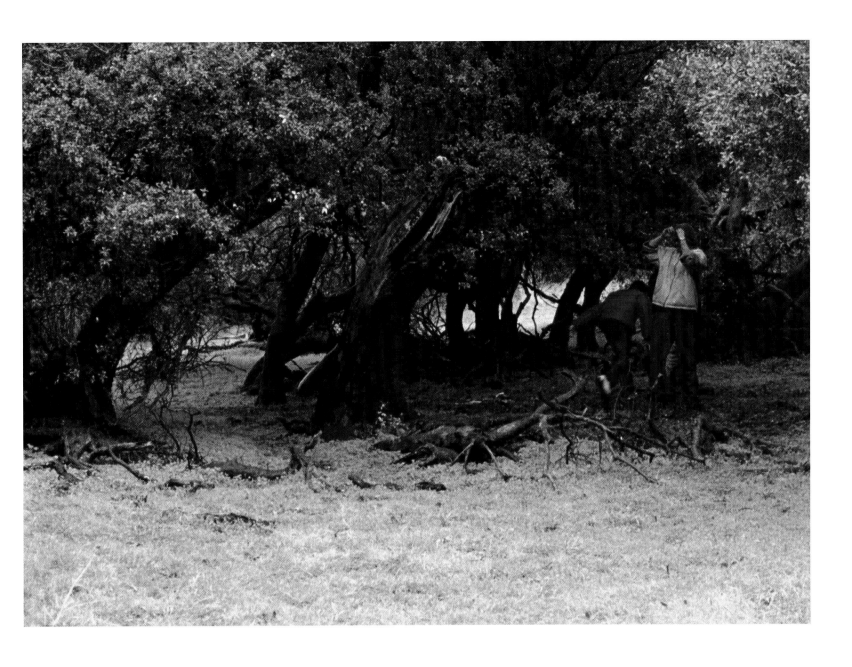

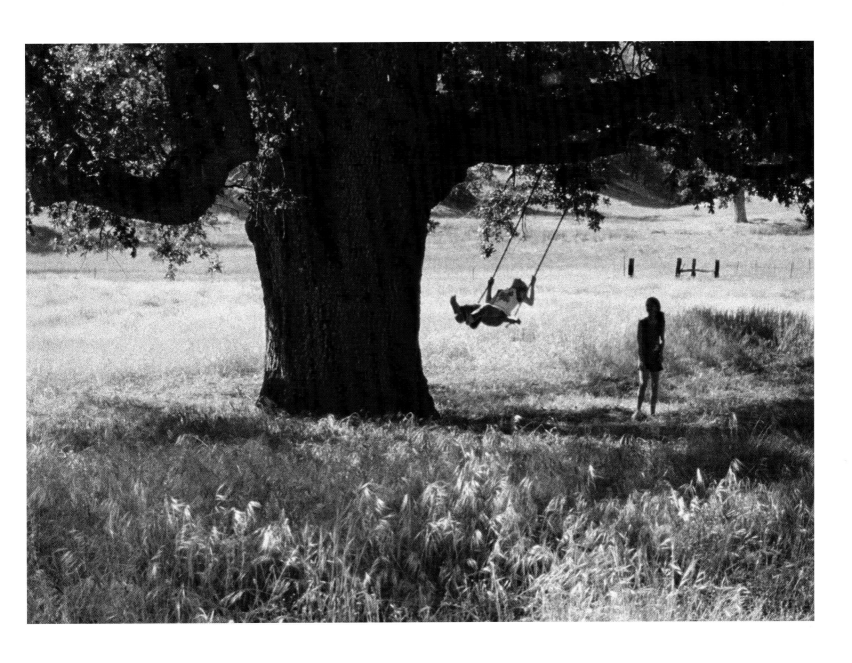

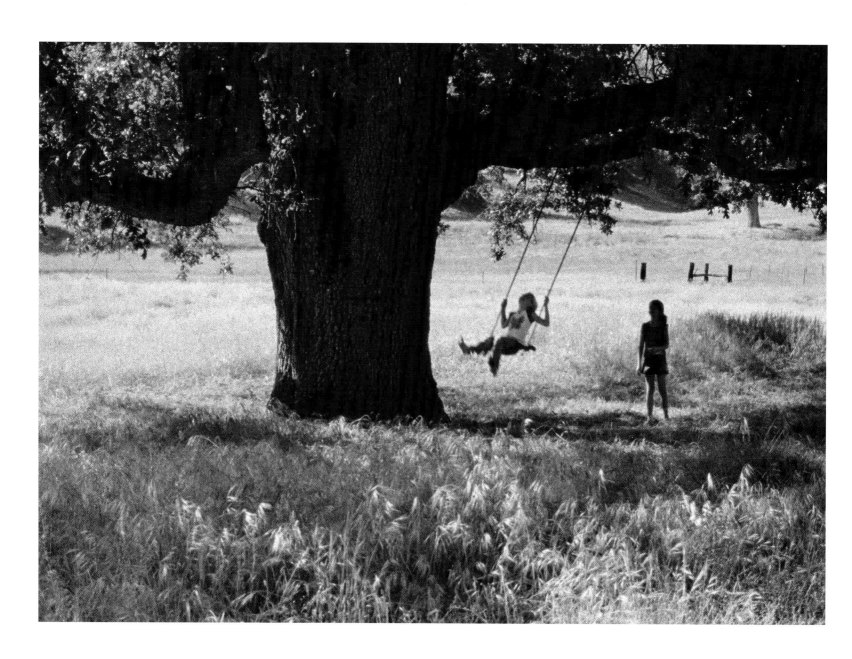

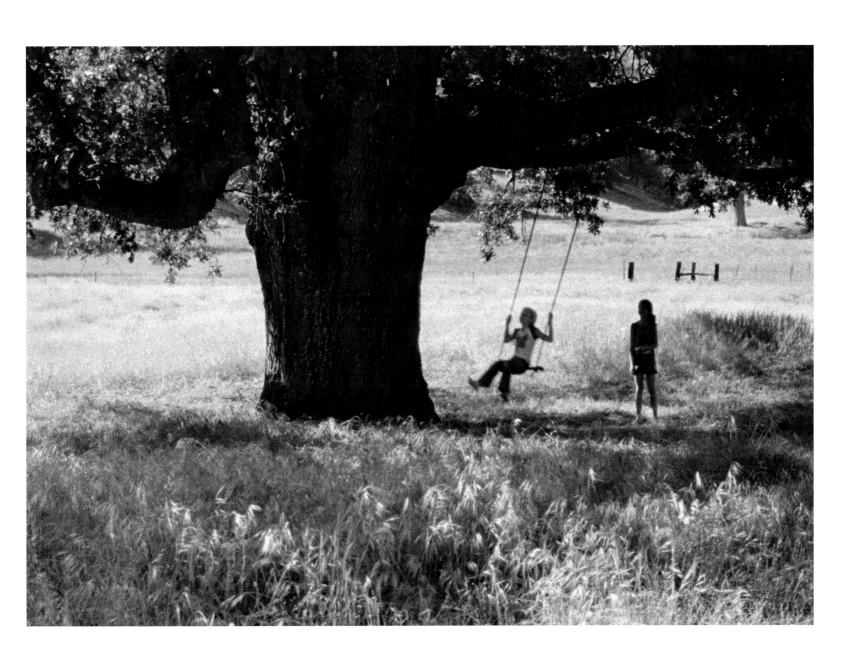

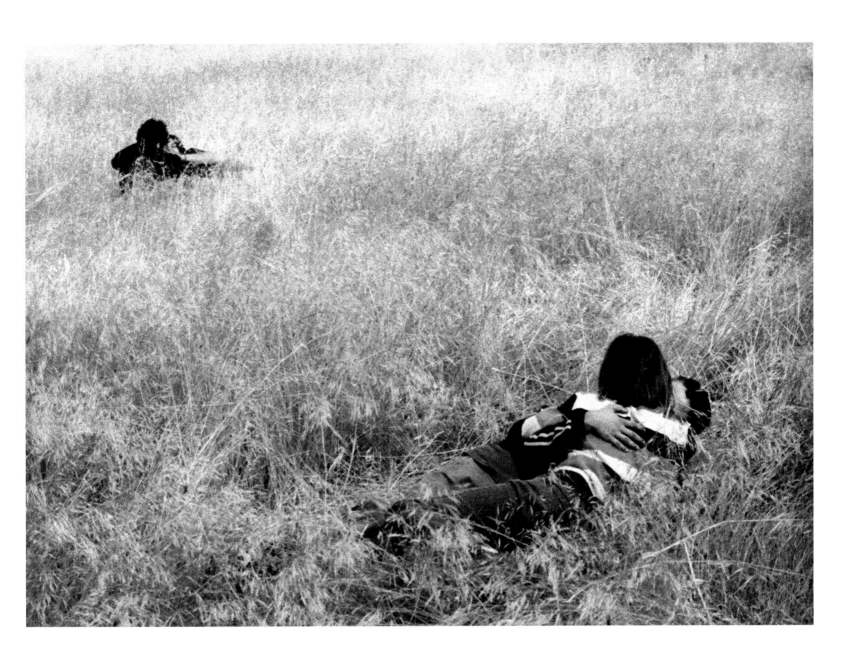

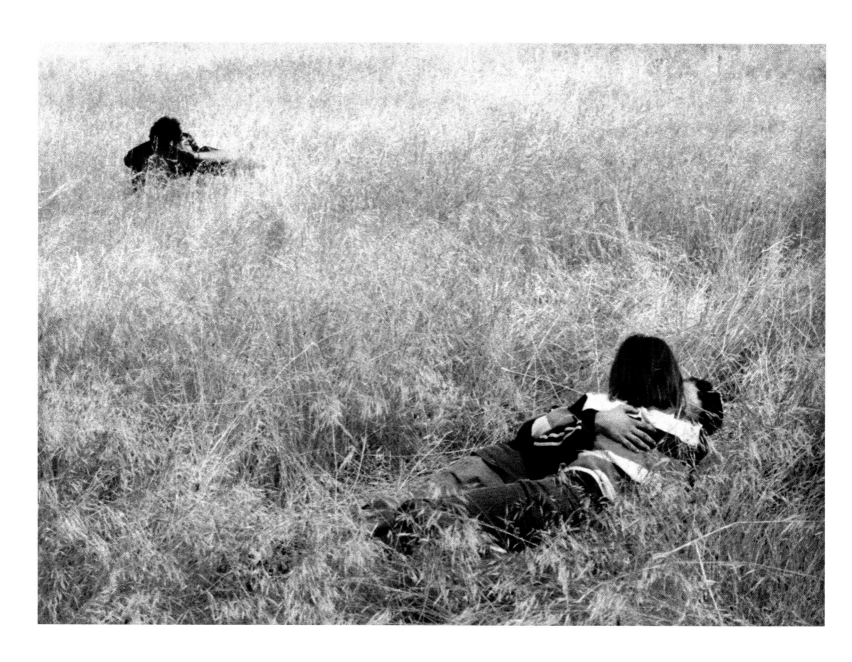

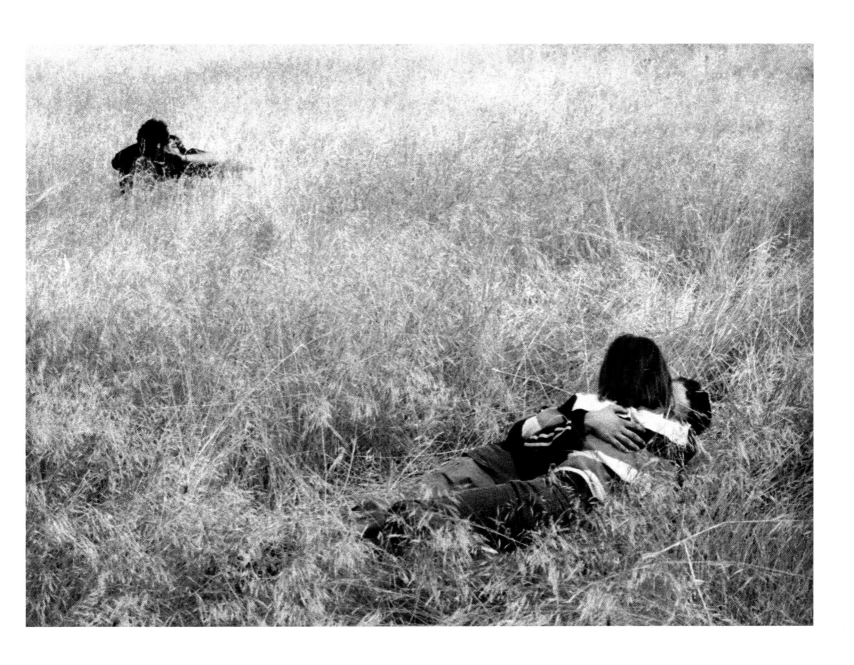

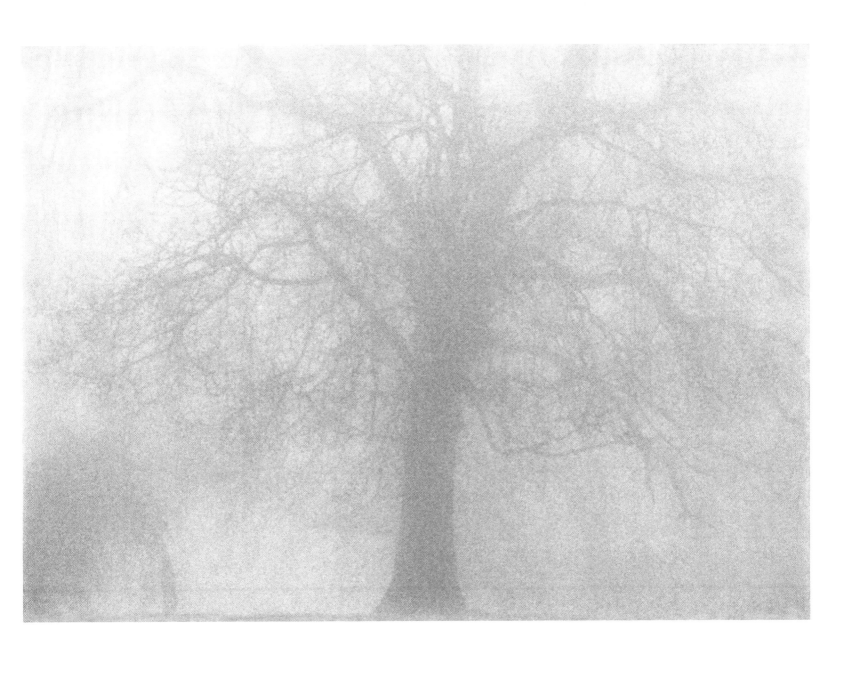

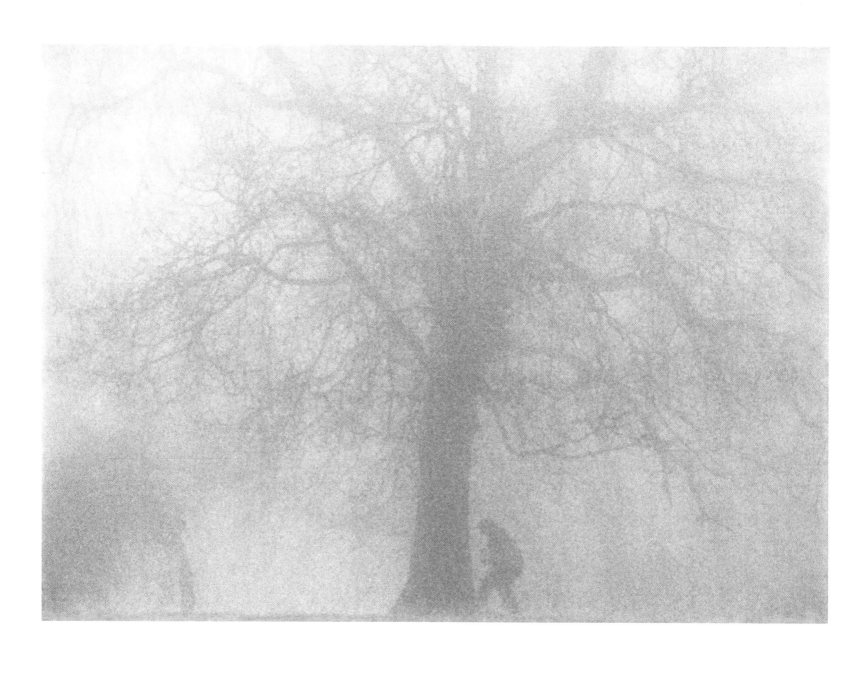

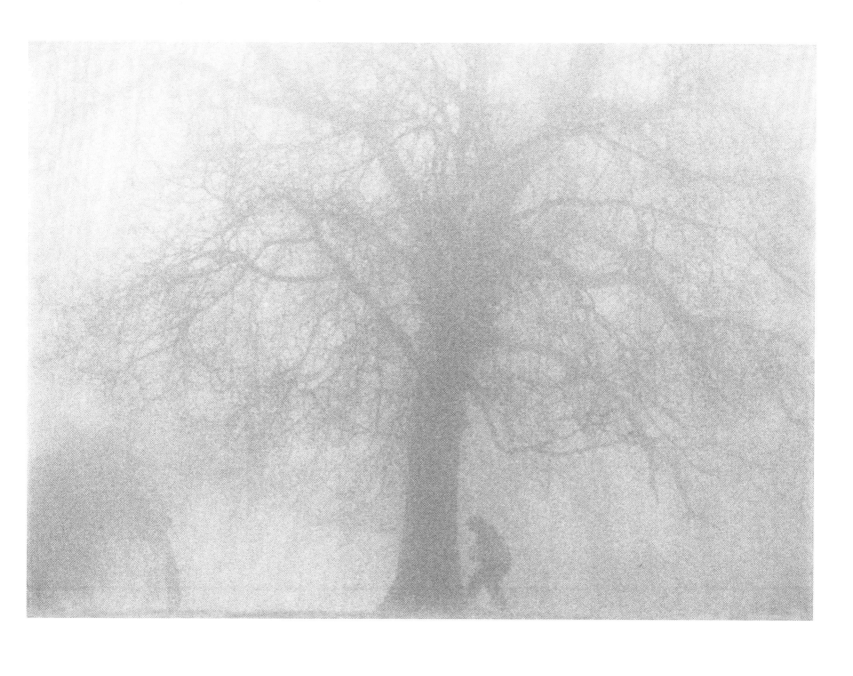

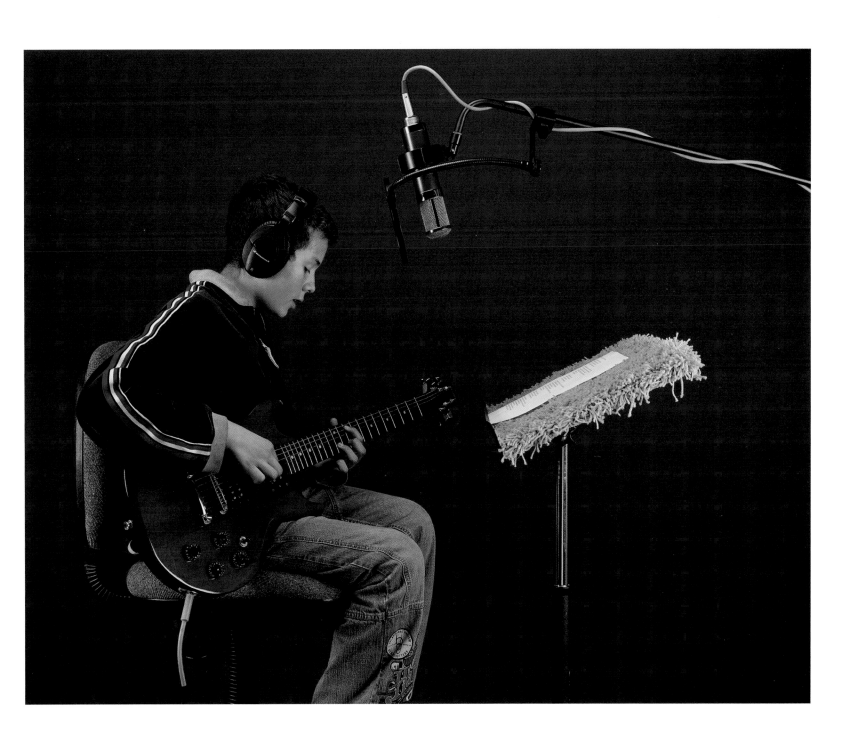

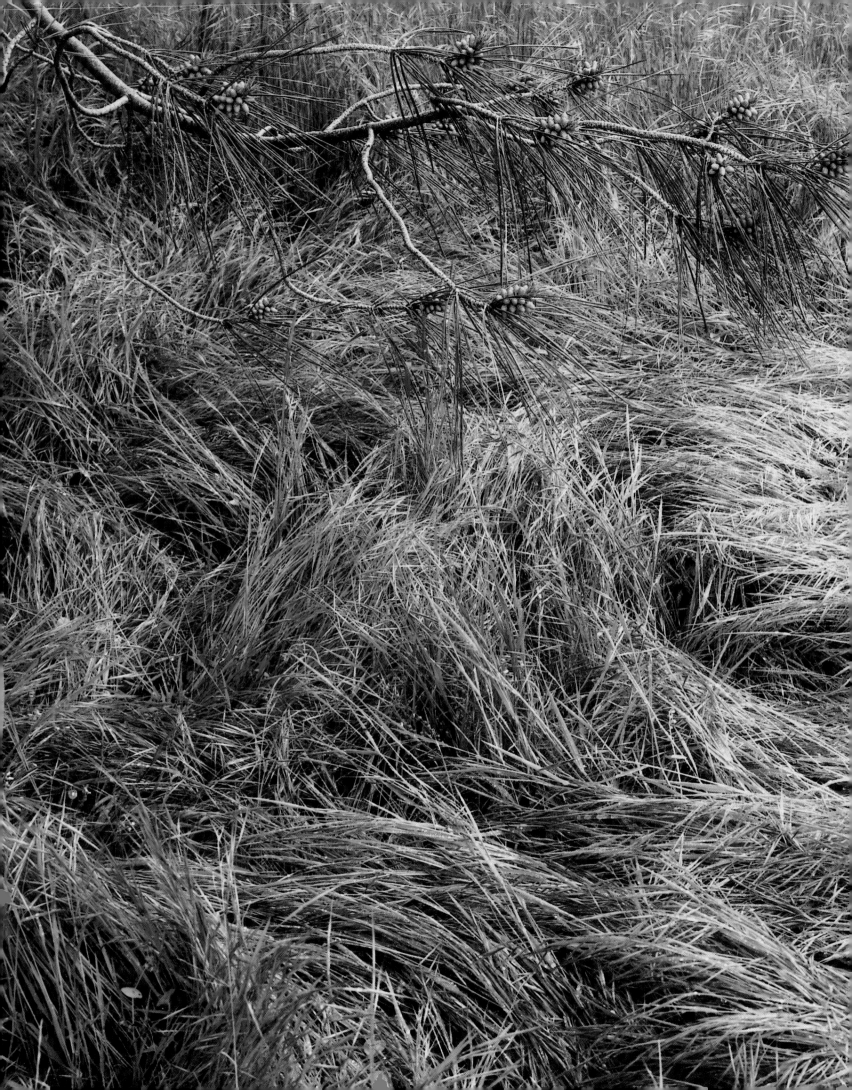

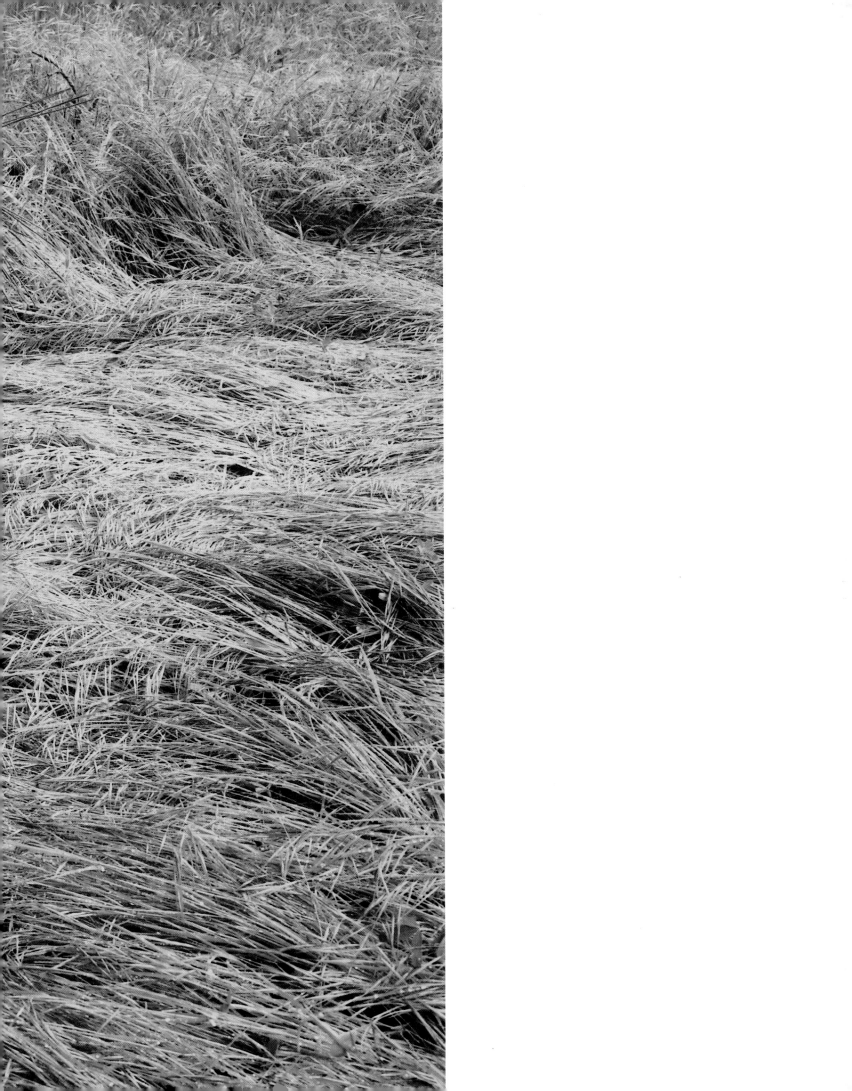

PINE

FLAT

SHARON LOCKHART

CHARTA

Published on the occasion of the exhibition
Sharon Lockhart PINE FLAT

Walker Art Center
Minneapolis, Minnesota
April 23–July 16, 2006

Arthur M. Sackler Museum, Harvard University
Cambridge, Massachusetts
August 26–November 19, 2006

Museu do Chiado - Museu Nacional de Arte Contemporânea
Lisbon, Portugal
October 3, 2006–January 7, 2007

Generous support for this exhibition was provided by
the Broad Art Foundation.

Design:
Purtill Family Business

Design Coordination:
Gabriele Nason

Editorial Coordination:
Filomena Moscatelli

Editing:
John Alan Farmer
Charles Gute

Copywriting and Press Office:
Silvia Palombi Arte&Mostre, Milano

Web Design and Online Promotion:
Barbara Bonacina

ISBN 88-8158-603-7

Edizioni Charta
via della Moscova, 27
20121 Milan
Tel. +39-026598098/026598200
Fax +39-026598577
e-mail: edcharta@tin.it
www.chartaartbooks.it

Printed in Italy

Contents

FLAT

SHARON LOCKHART

VISALIA

MT. WHITNEY
14494 ft.

SIERRA NEVADA

PINE FLAT

CORPORATE FARMS

99

FOOT HILLS

WOODY

ALLENSWORTH
FARM

KERN RIVER

KERN RIVER

CRYSTAL PALACE

GRAPES OF
WRATH

MOJAVE

BAKERSFIELD

BAKERSFIELD PALACE

MOJAVE

BAKERSFIELD

GRAPES

MERLE HAGGARD

PONY EXPRESS

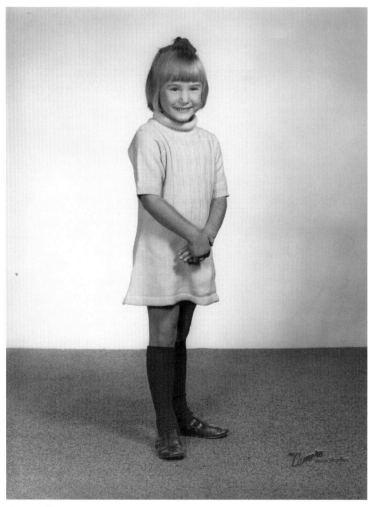

Sharon Lockhart, 1969

Shot over four seasons, time is the subject of Sharon Lockhart's *Pine Flat* installation, which consists of nineteen photographs and a 138-minute film, all of which are portraits of children. It is both a story of and a documentary about looking until one sees. As any artist or enlightened wizard will tell you, this sort of watchful resourcefulness involves embracing ambiguity to discover the beauty in and the intimacy that often springs from the accidents of life. Its absence accounts for the spiritual ache many adults experience as open-eyed innocence inevitably is lost in the process of growing up. We learn this lesson as children and, later, if we're open, can relearn it from them. After some years of necessary struggle, both parents and photographers recognize the pleasure, as well as the rewards, that result from locating the proper distance at which children can comfortably claim their independence and things come into perspective. As if to model this koan, Lockhart's purposefully unspectacular but exceedingly generous work allows both the viewer of and the children pictured in it to experience, over time, an increasingly intimate relationship with the world that is either physically occupied or portrayed.

The young people in the photographs and film came to know Lockhart over the four years she spent in their community, having rented a cabin by a creek to escape the unforgiving pace of urban life. Lockhart was surprised to find herself something of a pied piper; the children, immediately curious about the stranger in their midst, followed her around, inviting her to play and peppering her with questions about her life. But it wasn't until after a year of frequent four-hour commutes from Los Angeles to Pine Flat that Lockhart saw the possibility of creating art with the children who lived there. An intimacy with the place and people provided her with the necessary distance to begin seeing possibility. As the children scouted for the locations in which they would appear, they began to experience extraordinary places where, earlier, only quotidian spaces existed. As Lockhart says, "I would ask them what time of day a particular place looked best or in what season. Gradually they began to see." Eventually, in order to maintain the easy "emotional tenor" of their collective journey, the artist chose to keep the process of making art as simple as possible; eliminating her customary film crew, Lockhart taught herself to use a movie camera and employed

Becky Allen, a composer friend and frequent collaborator, to record the sound for the film. They often consulted with their mutual friend, the filmmaker James Benning, whose *California Trilogy* consists of thirty-five shots of the urban, rural, and natural landscape of the state, each 2.5 minutes long. The uniformity of the hypnotic structure of Benning's films mirrors the mesmerizing quiet of Lockhart's own fascination with an almost Zen-like repose. Questioned about this uniform structure, Benning references the origins of filmmaking, when films were shot not to construct a story, but to capture the sequence of life itself. "People would film a train coming into a station and they'd use the whole roll of film, capturing the moment from beginning to end."

When questioned about the structuralist underpinnings of her films, Lockhart counters that, while she is engaged by the motionless camera and the durational image of artists such as Hollis Frampton and Andy Warhol, she is less interested in making films about the "machinery of cinema" than she is in the possible emotional arc such extended looking creates. Perhaps this is why Lockhart, throughout her career, has returned repeatedly to directing young people. Some mix of empathy and shared memory—between the artist and her model, between the viewer and the viewed—inevitably surfaces when one comes face to face with a child. This identification creates an unusually large projection screen on which to transmit the twists and turns of one's own story of maturation and allows it to overlap another's. While Lockhart insists, "I'm so bad at telling stories," there is, perhaps, no plot to life or any narrative force greater than the inevitable connection between the beginning and the end.

From beginning to end, the action is languorous and the camera's position unchanging in Lockhart's color film, which is composed of two sequences of six portraits, each ten minutes long (or the length of a reel of 16mm film). A ten-minute intermission between the sequences consists of a black field with the word "intermission" printed in white letters and a sound track featuring the voice of a child singing a pop song. The first sequence depicts individual children; the second focuses on couples or groups, which reflects how a life is lived, since the transition from infancy to childhood is a story of increasing socialization. Each portrait is separated by six seconds of darkness, which, curiously,

draws the viewer into greater intimacy with the subject as if, once freed from the drama of narrative, we can savor the image longer; the longer we look, the more fragile or potentially precarious some of the conditions become. The two portraits at the beginning of each sequence are of a snowy, winter landscape. In the first, as the snow accumulates, an unseen child calls out repeatedly and with increasing concern, "Ethan, where are you?" (The film, in its entirety, answers that question.) The first portrait in the second sequence is composed of a group of children, none of whom are close enough to identify, who climb from the bottom of the frame to the top before disappearing entirely except for their laughter. Each portrait—child—required a different psychological strategy on the part of the filmmaker; despite varying levels of explicitness and repeated rehearsals, Lockhart never knew exactly how her direction would be interrupted or interpreted or how the emotion would build. For example, when the portrait of the boy in the woods with a rifle was originally shot on video, he surprised the artist by suddenly pointing the gun at her. A year later, when it came time to make the film, Lockhart set up the camera and left him to perform alone, judging he needed that distance to be himself; her only request was that he turn the gun at her camera again. Similarly, in the gorgeous portrait of two sisters' sharing a swing hung from the limb of an enormous tree, the seamless fluctuation between their playing and their fighting was a natural outgrowth of their relationship; however, the way in which the sound of an airplane suddenly penetrates the bucolic scene, disturbing its sentimentality, was a fortuitous accident the artist elected to preserve.

Like the film, the photographic portraits were similarly made without much obvious fanfare. Using only the natural light that filtered in through the open doors of the barn she used as a studio, Lockhart posed the children without props against an austere dark background, recalling the process employed by Mike Disfarmer, an eccentric photographer with an invented name who found his way to a small town in Arkansas and set up a commercial studio in 1914. Many of his restrained portraits also are devoid of props and shot against either a free-standing monochromatic or oddly striped backdrop; all were anchored in the northern light of his Ozark studio and captured the drawn but dura-

ble face of rural America as the Great Depression gave way to World War II. However, unlike Disfarmer, whose irascibility and emotional distress created a natural distance between him and those who paid to be photographed—according to historical materials, he never lost his outsider status—Lockhart came to enjoy the trust of the children, who welcomed the opportunity to have their pictures taken. Over time, as the children became more comfortable with both the camera and the artist, art began to be made, and artifice of a hauntingly beautiful sort replaced the snapshot. In the final images, all the children rather miraculously occupy the same proportion of the photographic frame, because of the mathematically precise relationship Lockhart sustained between the person and the camera. Each looks directly at the camera, and none adopts the silly deception exhibited by adults who force a smile for it. When the photographs are lined up, this strangely egalitarian composition makes it difficult to distinguish the ages of the children, robbing each of them of some small distinction and creating a system of unnatural similarities. The tender inquisition of the photographer's eye and her manipulation of reality accentuate their alikeness, mirroring the minuscule deviation of 0.1% in DNA that distinguishes one human being from another. When we learn about one, we recognize all. In many ways these images suggest a truth that weighs heavily on any responsible adult: a child's idea of life is a fiction—a futuristic imagining based on bits and pieces of parental or societal stories.

Pine Flat alludes to the multiplicity of these stories in contemporary American society. Growing up in a culture that constantly confuses one extreme picture of adulthood with another exacerbates the emotional whiplash that shapes adolescence in this country. Coming of age in California can be especially unsettling, as well as potentially liberating, because the state creates and circulates so many radically disparate systems for transforming values into youthful identities. Politically, it's a place of multiple personalities. For example, the pernicious conformity of the postwar era found its most extreme embodiment in Orange County with the founding of the John Birch Society in 1958, while the counter-cultural challenges that followed in the 1960s were incubated nearby. These viral reactions included both the psychedelic abandon of Haight Ashbury and the rage of the Los Angeles riots, sparked by

California's explicit attack on the fair housing section of the Civil Rights Act. It's perhaps not accidental, then, that many of the most complex and memorable pictures of adolescence originate around Hollywood.

There is perhaps no more enduring filmic incarnation of the emotional tremors that separate young people from their elders than James Dean. Born on a farm in 1931 and raised by an aunt and uncle, Dean was the insecure and sexually ambiguous answer to those who questioned the conventionality of the Eisenhower years. Starring in only three films, including John Steinbeck's semi-autobiographical *East of Eden*, which is rooted in the soil of California's Salinas Valley, Dean's improvisational approach to creating the troubled characters he inevitably played reflects a personality in formation, as well as a rebellious style of acting. This disconcertingly fretful method agitated his more experienced and less experimentally inclined co-stars, accentuating an emotional imbalance that directors such as Elia Kazan manipulated to shape the fictional relationships represented in the film. Despite his moody individuality, Dean's death at twenty-four in a car wreck wasn't all that unusual, mirroring countless adolescent adventures played out on California highways built to accommodate an undying love of the car and the freedom it affords. It's a passion that annually results in the highest number of highway fatalities in the nation. Dean died when a speeding car driven by a college student crashed into his silver Porsche at twilight on a California highway eighty-three miles from Bakersfield.

About an hour's journey northeast from Bakersfield, the town of Pine Flat is not an easy place to find. A stranger most likely would discover it accidentally. Even an extensive Internet search reveals little about this working-class community of three hundred, tucked in the foothills of California's Sierra Nevada Mountains, where, in 1848, the gold rush began along the American River. From afar, or at least from the way it first appears in Lockhart's film, this is a landscape of edenic possibility in which children are free to be (or, perhaps, since this is a work of art, free only to play at being) children. While an occasional moment of self-consciousness interrupts their poses, these young people occupy nature comfortably, finding ample pleasure reading in a field or learning to play a harmonica by a stream. Often centered in the frame, they inhabit the terrain: swimming, swinging from a big oak

tree, wrestling, sleeping amidst leaves, nuzzling each other, and waiting, hunting rifle ready. The remarkable collective poise of these untrained actors is a sign that they are doing for the filmmaker what they've done before for themselves. Melancholy moves across a face just as an intimation of violence drifts through a scene, but, basically, these are portraits of children and adolescents who know both who they are and who the woman behind the camera is. They look perfectly natural, almost.

As in any representation of paradise, all is not as it seems at first glance. The sound track complicates this pastoral picture, punctuating bird songs and rustling leaves with the occasional buzz of a car, bus, motorcycle, plane, or gun shots. The unseen vehicles—only a school bus crosses the screen—operate as auditory ghosts, signaling the adult world that exists entirely outside the frame, as no grownups populate Lockhart's film. This bodily absence is an accurate reflection of life in Pine Flat, where most adults disappear during the day. Once the ranches that provided employment to many of Pine Flat's families vanished, the population grew more dependent on neighboring cities such as Bakersfield, one of the fastest-growing communities in the United States. It's not hard to imagine a working mother and father descending the mountain at sunrise with the car radio tuned to the "Bakersfield sound," a style of country music influenced by rock and roll and invented by Merle Haggard. The children remain behind in the one-room, twenty-three-student school. Being alone, they readily accept a stranger and play for her camera, so that their experiences become hers and then ours. In performing new roles, they safely experiment with the expectations and adapt to the increased self-awareness of an adult world. And yet, in Pine Flat, they seem happy to remain children—beautiful and believing, complex and complicit. This is a story many of us find hard to believe.

Who, then, are we who look, projecting our own inner pictures—dreams of paradise and loss—onto America's children and the landscape (or what remains of both)? How is it that this tiny homogenous community, which sidesteps the overtly sexual, violent, and often urban (if not suburban) pictures that spring from Hollywood, can represent us all? The miracle of art is that it allows for seduction—to deeply invest, if only for ten minutes, in the life of another. By creating both a methodology and a composition that models the best of adult behavior, Lockhart permits us to invent a connection to or portrait of another plus one, suggesting that each of these children are us. We yearn for more such stories even when we know we have destroyed our own capacity to believe in them long-term. So, sometimes, we flirt with notions of a far-off paradise, forgetting that Adam and Eve lived in a place where only the self-conscious serpent could be considered adult. Lockhart's *Pine Flat* shows us an alternative to the venomous and punishing need of adults to seize upon the small differences that separate and shame us. Through her own ability to allow her authority to be challenged and changed—made more forgiving—by a child's need to repeatedly invent, test, and discard reality, Lockhart restores the innocence of a young person's world. This paradise is retrievable if we look long enough to cede superficial control. As any good parent, Lockhart allows her children to live lives independent of her desires; in doing so, they show her a new way to create a luminous fiction. Just as Lockhart came to the town of Pine Flat by chance, it is her embrace of chance that allows *Pine Flat*, the installation, to capture our humanity and dreams so fully. It is a work made out of watchfulness, empathy, and trust, both received and given. Here light makes lasting images and darkness recedes, for a moment or two.

Kathy Halbreich has been director of the Walker Art Center since 1991, where she has organized exhibitions of work by Chantal Akerman, Craigie Horsfield, and Bruce Nauman, among others.

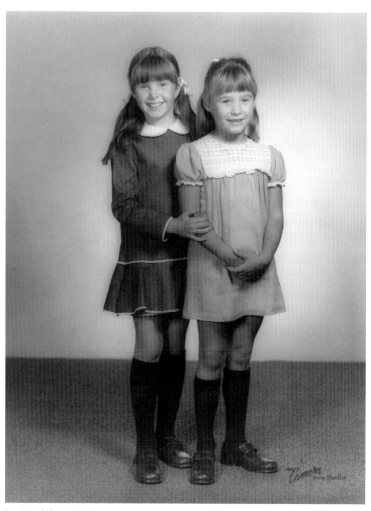

Laurie and Sharon Lockhart, 1970

Sharon Lockhart's projects usually begin with a concept, through which she then finds her subject. For example, for her 1999 film *Teatro Amazonas*, she began with the following concept: shoot a thirty-minute roll of film, from a single angle, of an audience listening to a piece of music created as a score for the film. This device led her to an historical opera house in Manaus, Brazil, which only then led her to the people who would become her subject: the 308-member audience featured in the film, each member of which she interviewed and selected personally in collaboration with a demographer to create a representative cross-section of the city's population, a portrait of Manaus. She arrived at her *Pine Flat* project somewhat differently, however: one could say its subject, or subjects, found her. Looking for a place to get away, she has said, she almost accidentally happened upon the town, a former ranching community in the Sierra Nevada foothills, now a bedroom community for families who find their work down the mountain. And given its demographics, during the day Lockhart often found herself the lone adult amidst the town's children. That fact, coupled with her contagious curiosity and ease in their company, gradually led the children to approach her. Lockhart being Lockhart, a film began to crystallize. Pine Flat, the place, began to metamorphose into *Pine Flat*, the project.

My first encounter with the project came in December 2003, when I saw rough cuts of several shots that Lockhart had made for the film *Pine Flat*. All summer scenes, they included segments of the completed film portraying two sisters swinging, two children playing in a creek, and a boy playing a harmonica. One might think that the startling, real-time stare that Lockhart imposed on each scene's subject, the fixed-camera calm that allows the eye to take in the scope of each frame and its myriad details at the pace of activities as quiet as reading or sleeping, would have left the most conspicuous first impression. But what struck me most viscerally on that first screening was the incredible luminosity of those ten-minute-long shots: the densely concentrated color and pervasive all-over light. Qualities that should have cancelled each other out instead intensified each other, a doubling that in turn catalyzed a certain psychological urgency, underscored by the only partially audible ambient sound. Curiously, for me these formal environmental effects preceded any real register of the children the environment

contained. But once I acclimated to the environment of each shot, the children themselves riveted my attention. Lockhart's tightly controlled compositions, coupled with her painterly treatment of the images, had focused my gaze equally on landscape and figure, though not necessarily simultaneously, by making each distinct yet interdependent, and by giving the viewer sufficient time to look. I became intrigued by her transformation of the play between figure and ground in formal terms into a meditation on what it might mean to reside in this community. Through her active involvement of the Pine Flat children in the practical realization of the film, Lockhart appeared to be transposing a minimalist aesthetic of repetition into a sociological preoccupation with habitual behavior and everyday activities while reclaiming the ethic of collaboration with one's subjects advocated by the filmmaker Jean Rouch. Even in those first rough cuts, I was impressed by the equivalence she established between a painterly figure/ground and a more ethnographic subject/field.

Like Lockhart's previous photography and film projects, *Pine Flat* is predicated on an engagement with a community—in this case, her personal experiences with the children, who in many ways stand for the town as a whole, and with a place that she felt connected to in part because it is similar to places where she grew up. In its totality, *Pine Flat* comprises three correlates for the community: a film, a series of nineteen photographic portraits of the children who live there, and a series of three photographs representing the landscape at different times of the year. The film is structured as two halves: the first half consists of six ten-minute shots, each featuring a single child absorbed in a solitary activity; the second, six ten-minute shots of pairs or groups of children interacting with one another.[1]

Like Rouch, in *Pine Flat* Lockhart refuses to feign objectivity, to use the camera merely as a recording device or to suggest that it creates the reality observed. The camera that she used to shoot the film—the first film she shot herself, without a film crew—was crucial in this respect. For this project, she purchased and used an Aaton camera—a 16mm camera invented by the engineer Jean-Pierre Beauviala in 1967 and first used widely in the political filmmaking that emerged out of the events of May 1968 in France.[2] This camera provided filmmakers with a single reference to both film and audio takes by clearly indicating on the film stock, as well as on the magnetic tape, the precise time that it recorded the images and the sounds. While until then conventional filmmaking had to resort to artifice to show the existence of two different but coterminous realities, the Aaton enabled filmmakers to reconstitute the simultaneity of events after the fact. It consequently revolutionized filmmaking for a generation of politicized filmmakers, ranging from documentarians such as the Maysles Brothers, to directors such as Jean-Luc Godard and Louis Malle. It permitted Lockhart to examine the camera as an extension of the director's way of seeing, to bring art and life closer together, and to open up new, more personal yet more analytic possibilities for an artist seeking to create a portrait of a community.

Indeed, what we perceive in *Pine Flat* is a certain affection between director and actor that resembles parenting at its best: Lockhart appears to enable the children to play themselves. As a result, the performances they offer up feel neither acted, nor surreptitiously observed. Almost without exception, there is an absence of both self-consciousness and posing. In fact, her efforts to work collaboratively with the children to select and reconstruct activities that feel familiar and routine, but not obligatory—to structure play as work—is integral to her direction. Hanging out with the children leveled the playing field, allowing her to communicate outside the proscribed role of "adult" and to initiate this collaborative process. Together, she and the children crafted a series of activities that simultaneously seem natural while calling attention to all that is artificial in the filming. For example, even in an activity as near-static as that of the girl reading on the grass, the trailing of eyes along lines of text and the allotment of time before a page is turned, the action of turning a page comes off convincingly: the reader seems to be genuinely absorbed in her book, yet we can also feel Lockhart behind the camera, equally absorbed, waiting to be surprised. This is not to say, however, that there are not moments that feel a bit like working at play, as when we are made to squirm along with the boy playing the harmonica as he finds himself flicking bugs off his skin.

Amidst this familiarity, Lockhart persists in establishing distance from the children. First, as in her previous films, she imposes a seemingly

objective structuralist logic—namely, the decision to divide the film into twelve ten-minute-long continuous shots. Second, she is at pains to reinforce a sense of intense remove from commercial culture, hemming her shots with stands of trees or horizon-less fields and pools, introducing the external world only via the children's contemporary clothing, sometimes emblazoned with logos, or the sounds of cars, trucks, buses, planes, or gunshots. And third, the children's activities, however carefully culled from conversations with and observations of the children themselves, are formalized and limited to small movements or repeated sounds—the sleeper's twitching feet as he sleeps wedged between a few rounded rocks on a mossy knoll, the reader's turning pages as she reads on the grass, the hunter's flicked sticks and slowly scanning gaze as he waits for prey in the forest, the hands-in-pocket-rocking-steps of a boy standing alone in the landscape, waiting for his school bus to ascend the foothills spread below him.

As these brief descriptions suggest, Lockhart insists on locating each of these children in a landscape, which she posits as a containing structure, and on giving them roles to play. Within this containing structure, and within the roles she contrives, their personalities spill out through the little leakages that occur as a result of the unplanned accident, the things that defy her control. The heightened perception she makes possible in this way allows every blip, laugh, shout, or lifting of a gun to register. Lockhart reinforces this attention to isolated gestures by repeating certain isolated formal effects in otherwise different scenes.

I am not the first to observe, for example, that Lockhart begins and ends her film with frontal shots of figured landscapes veiled in neutral precipitation. Snow steadily falls in the first shot, as a girl searching for her friend cries, "Ethan, where are you?" A gnarly, fog-enshrouded oak tree occupies the full frame in the last shot. And the second half of the film begins with a snowy scene in the forest shot from above and on a clear day, foregrounding a meander of dark tree branches and the upward zigzag path of a group of children who enter the frame from the bottom, ascend the hill, and then exit the frame from the top. The cumulative effect of these three shots is both to envelop the rest of the film in a kind of insulating whiteness and to thread the two halves of the work together. Lockhart uses flashes of red similarly throughout the film, primarily on the children's clothing, to create another more subliminal weave, or counterpoint, to the mostly modulated and tonal landscapes within which she sites the children. This intensification through repetition is one of the many ways she builds complexity, moves the film forward, and allows abstract formal effect to register psychologically without resorting to narrative.

For pure painterly complexity, the shot of the boy and girl playing in the creek is incomparable. Positioning the girl, wearing a pale pink shirt, and the boy, shirtless and with pale white skin, like a nucleus in the center of the concentrically rippled creek, she surrounds these two figures with a flattened reflective field of dappled color—blues and pinks and yellows and oranges. The effect is more Claude Monet than Monet himself, as if Lockhart had captured the source of his interest in refracting light as color. More to the point, though, is how Lockhart neutralizes this aggressively beautiful scene by recording the children's running chatter as another kind of abstract dapple, only occasionally broken by one of them breaking the surface to dive for a fish.

The near-perfect equilibrium in this scene between children and creek creates a sense of something close to harmony, of a calm that the next scene, in which two boys and a girl use Airsoft pellet guns to intensify the emotional anxiety of a teenage triangle, disturbingly disrupts. Lockhart has said that for the film, the more natural a subject is with regard to his or her surroundings, the greater the appearance of artificiality, and these scenes seem to make us conscious of her point. The creek scene, in which the innocence and absorption of the children in their conversation and play enable us to relax enough to enjoy the scenery, as it were, as parents do when their children seem safely occupied, makes us conscious of the exaggerated painterly effects Lockhart contrives. In the pellet gun scene, the awkwardness of children of that age, and the effort that this awkwardness imposes on even the most spontaneous gestures of affection or aggression, make us equally conscious of things like rain and the calculated contrast of red clothes against verdant green woods. This scene has more spontaneous action, more swearing, more erotic charge, than any of the others; and Lockhart's selective amplification of the conversation and the sound of the rain only intensify the sense of anxiety it interjects. Again, the full effect owes to the equivalence she

establishes between the darkly dense stand of trees that cut through the middle ground and the almost stereotyped adolescent segue from flirt to taunt. This is one of the few scenes in which the children move *behind* a barrier of sorts, into a space that could be less protected. But overall, the painterly composition again contains the action.

More abstractly, the almost obvious formal/psychological equivalences I am trying to sketch—between innocence and light or adolescence and shadow and between the more over-arching containment of activities that seem just short of absorbing, restless and latent with an anticipation of change—extend Lockhart's long-standing interest in ethnographic photography and filmmaking, her desire to give herself permission to look at people who interest her, to stare as we stare at figures in a painting. Timothy Martin has written about some of the ways that Lockhart "defers the individual" or distances herself from her subject by formalizing and abstracting her presentations, something he wants to call camouflage—for example, Khalil's makeup in *Khalil, Shaun, A Woman Under the Influence*, the aggressively choreographed exercises of the girls' basketball team in *Goshogaoka*, and the conspicuously conventionalized presentations of the families of the island of Apeú-Salvador in her Amazon River Basin project.[3] He sees her imposition of obvious artificiality as a way to evade being co-opted into critique. What she seems to posit instead is a type of rhythmic repetition that we register as meaningful, but cannot interpret, as in the complementary pairings that take place first in the creek segment, then in the swing segment, and then in the segment featuring two young couples, where the two centralized pairs of the earlier scenes seem to be centrifugally pushed to the edges of the frame. Cumulatively, the succession of carefully crafted records begins to suggest something more psychologically complex, a kind of anti-spectacular weaving of figure and ground, or subject and field, that approaches both the integration and the anxiety of Jackson Pollock at his most abstract.

About ten years ago, Rosalind Krauss made some observations about figure and ground and resistance to spectacle that seem relevant here.[4] Her remarks were reactive, an effort to pin down some of her misgivings about a tendency she ascribed to the practice of cultural studies and its visual culture offspring—specifically, what she read as a postmodern tendency to collapse the material signifiers of an image into a more psychoanalytic Imaginary, or hallucinatory projection—and to link this interpretive practice to an earlier formulation of art historian Michael Fried's, in which he proposed an "optical" reading of "the relation between figure and field," in lieu of Clement Greenberg's spatial one, in Pollock's late 1940s, all-over painting.[5] More broadly, Krauss was grappling with a tendency to generalize the condition Fried called "absorption." At the risk of entirely flattening her argument, her particular concern had to do with the similar operations entailed in what Fried called Pollock's "cutouts"—figures isolated from their background that the viewer registers as blind spots and that Fried saw as something "registering an absence," "not experienced as actually occurring within the space of the painting," and "utterly resistant to signification," and what Lacan referred to throughout his mirror-stage essay as "recognition-in-imitation." Krauss's argument hinges on her detailed reading of a process of projection onto, and interpretation of, forms read not as figures per se, but as these "cutouts" or "blind spots" or mirrors. The problem for Krauss is that a coalescence of form, a form that distinguishes itself from the field without becoming fully a figure, is not understood as dynamic tension *within* the field, but as something that "drops out," becoming a surface onto which we project an identity.

What I am trying to suggest here is that Lockhart's careful calibration of everything from the tonal mix of the seemingly casual apparel that the Pine Flat children wear in the film, to the capture and manipulation of light and sound effects that weave the children inextricably into the landscape, to the precisely deflected gazes that make it impossible to make eye contact and the subtly disjunctive interruptions that shift focus or direction and snap us to attention, effect something entirely anti-spectacular and make it impossible either to project an identity or to formulate a conventional character or ethnographic "type." In the film, one could argue, the equivalence Lockhart establishes between figure and ground allows her subjects to assert their individuality *within their environment*, precisely because she so carefully controls the containers she constructs for them.

Something different becomes apparent in the photographic portraits that comprise *Pine Flat Portrait Studio*. In the tradition of a late-nineteenth or early-twentieth-century portrait photographer, Lockhart opened this studio in a barn in the center of town. The children could come to the studio whenever they wanted and have their portraits taken as they were, and Lockhart has said she particularly relished the ways in which this open studio setup recapitulated her initial encounter with the children, as a result of their approaching her. So that they could see the results of each shoot almost immediately, Lockhart used a large-format camera with the capacity to make Polaroids, which she would show to the children, as well as 4 x 5 negatives of the same frame. In these photographic portraits, in contrast to the filmed ones, the "container" is not the landscape, but a black muslin backdrop. This backdrop acts as a foil that intensifies the details of the children's gestures or clothing by throwing them into high relief—a very different effect from the film, one that is amplified by the children's direct gazes, which contrast with the assiduously deflected gazes of the children in the film. At the same time, Lockhart increases the children's potential for individuality by allowing them to wear outfits of their own choice as they pose in front of the black field. Although she must have had a fair amount of say in their poses and expressions, as a group these portraits are affectionately defiant and assertive. Lockhart seems to have transmitted the pleasure of performance. Perhaps as a result, the children in these photographs enter our space.

Pine Flat is not Lockhart's first project focused on children. *Auditions*, her early series of photographs of children restaging a sequence from François Truffaut's 1976 film *Small Change*; *Khalil, Shaun, A Woman Under the Influence*; and *Goshogoaka* each enlist a certain combination of adolescent guilelessness and blankness to explore the formation of character through habit. But Lockhart's focus on recreation and play—on something elected and not obligatory—may be the most significant shift that the *Pine Flat* project introduced into her long-term investigation of habit and work. Ignoring, for a moment, his more deceiving manipulations, Lockhart seems to have played something of the role Tom Sawyer made infamous when he cajoled his friends into painting Aunt Polly's fence. Or rather, she seems to be

asking the same question that he asked those friends: "What do you call work?" Four hours from home, with a group of children she invited into her creative space, she also seems to have arrived at the answer Twain gave to his character's question: "play." "Work," said Twain, "consists of what a body is obliged to do; play consists of what a body is not obliged to do." By allowing the kids she came to know to perform themselves in the studio, Lockhart allowed them to make play of their work, and work of their play.

Notes
1. For the first time, Lockhart has devised distinct film presentations for the theater and the gallery. For the theater, the film is screened as a 138-minute-long feature, with the two halves separated by an intermission. Ten minutes in length, the intermission is a black screen printed in white with the word "intermission"; the soundtrack features Balam Garcia, one of the children who worked with Lockhart, covering a pop ballad by Blink 182, with the refrain "So here's my holiday." For the gallery, each day, one consecutive segment from the first half of the film and one consecutive segment from the second are respectively shown on continuous loops in two discrete but linked screening rooms. A separate room includes a turntable and an LP record featuring Garcia's covers of pop songs that he likes and a large photograph of him recording the LP in an interior space.
2. Information about the Aaton camera in this paragraph is drawn in part from Jean-Michel Frodon, "The Modern Age of the French Cinema From the New Wave to the Present," Aaton (2006), available at http://www.aaton.com/about/history.php.
3. See Timothy Martin, "Documentary Theater," in *Sharon Lockhart: Teatro Amazonas*, exh. cat. (Rotterdam: Museum Boijmans Van Beuningen and NAi Publishers, 1999), 12–30.
4. See Rosalind Krauss, "Welcome to the Cultural Revolution," *October*, no. 77 (Summer 1996): 83–96.
5. See Michael Fried, *Three American Painters*, exh. cat. (Cambridge, Mass.: Fogg Art Museum, 1965).

Linda Norden is Associate Curator of Contemporary Art at the Harvard University Art Museums. She recently served as Commissioner for the U.S. Pavilion at the 2005 Venice Biennale, where she curated, with Donna De Salvo, Ed Ruscha's *Course of Empire*.

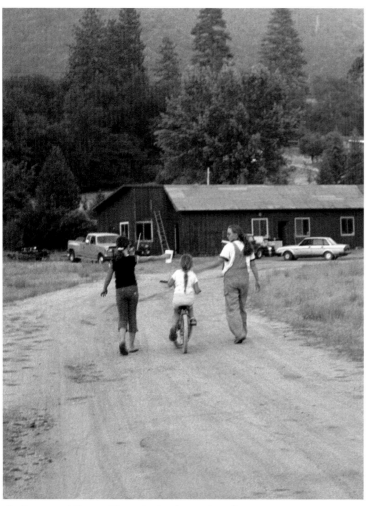

Alex, Breanna, and Sharon walking to the Pine Flat Portrait Studio

One of my five half-sisters called me from the Sundance Film Festival. She wanted to let me know she had just seen Sharon's new film. "I think I know why it's in the so-called Frontier category," she said, and reported that early on, in a scene that consists of a ten-minute-long shot of a young girl in the grass reading a book, a few people in the audience clapped whenever a page was turned. I guess, in their eyes, nothing was happening. But quite a lot is always happening—is it not?—between each turning of the page.

Being a mother, I can't count the number of times people with kids have said to me "they grow so fast" or "you better enjoy this stage, it'll be over before you know it." The gist is that growing up is difficult to perceive—maybe precisely because it's happening all the time right before your eyes—yet given all its imperceptible slowness, it still happens painfully too fast. I suppose the degree of pain here depends on the ratio of what is lost to what is gained. If you've raised yourself a fine young adult who is a continuous source of pride, then maybe it's less painful to close the book on your child's childhood than if, conversely, you've raised yourself a troubled individual, susceptible to drug abuse, whose most adult characteristic is his or her ability to reproduce or be incarcerated.

What lies between these extremes is, perhaps, a bit boring. Like the impatient audience members at Sundance, we are often more inclined to focus on obvious indicators of progress and change, less inclined to patiently observe those myriad illegible, seemingly insignificant moments which ultimately add up to the people we become.

As much as there exists in all children the potential to thrive and lead happy or productive lives, there is equally the potential to waste away and to lead unhappy or unproductive lives. For kids these days, or for the kids in my life anyway, the chances of falling through the cracks seem greater than ever before. One could argue a myriad of socio-political reasons for why this is or is not the case. Let's just say that it is indeed true—if only for the sake of my getting on with my story—that many American kids have the deck stacked against them. You could blame it on the junk food forced on them by big corporate interests, or simply a school system that teaches less and penalizes more, or you could even blame it on the erosion of family values.

One of my other five half-sisters called me from Missouri the day before I took my one and only trip up the mountain with Sharon to visit Pine Flat. She left a message saying the Christmas card she sent had been returned and that she hopes I call back and something else that made me feel positively awful about my never returning her calls. This sister entered my head the moment Sharon introduced me to the first people we saw walking down the main street of the tiny town. It was a couple, around my sister's age, ten years my senior, on their way to the bar. Apparently no strangers to cigarettes and alcohol, they may—I imagined—have been a bit buzzed already. They may not have been, but they did look relaxed and especially young and old at the same time, like a couple of sweethearts taking a psychic break from a series of wearying hardships.

I guess, to be honest, my imagination turned them into members of my own family. I was specifically thinking of how my sister, whom I had yet to call back, had once moved to what I thought was the middle of nowhere with her boyfriend (technically our cousin, though not an actual blood relation) and wound up having his baby out there. She's not the only sister of mine to take off for a rural setting. I always resented the fact that they left for these remote places but never managed to live off the land or do anything especially rural with their lives. It was like they had this quasi-hippie idea, from too many Hallmark card images of grassy fields or posters of mossy creeks, that the less culture that littered the scenery, the freer they'd be. The funny thing is there never seemed to be an excess of freedom out there.

After being in Pine Flat for about fifteen minutes, my old, naïve question of why anyone who wasn't actually from the middle of nowhere would want to be in the middle of nowhere, suddenly became, "Who could resist this middle of nowhere?" Sharon's success as an artist affords her the freedom to occasionally get away from her hectic, congested schedule. The mountain, I'm sure, was originally for her a getaway, an oasis. I'm not sure, though, how long it was before she decided to set up a studio there, or how soon after her studio became Pine Flat Portrait Studio, or how soon after that every kid in town knew her car and would run up to it to greet her whenever she arrived. I do know that once in Pine Flat, she started doing mostly everything herself, a significant reversal from the way she had been making films and photographs for at least a decade.

Sharon's portrait studio, and by extension her whole artistic practice, carved out a space for itself in a place that didn't necessarily have any room for, or even a need for, that kind of activity. Pine Flat Portrait Studio was not church, not school, not home. I have come to think of it as a one-woman YMCA. (It is probably more accurate to call it a two-woman YMCA, as Becky Allen, who recorded all the sound on the film, was a permanent fixture.) The spirit of this one-woman YMCA is one of cooperation and improvisation and has everything to do with paying very close attention to what and who surrounds you. And this paying very close attention to what and who surrounds you has everything to do with art. And art can drastically alter the course of your life, generally for the better. I know this to be true for me and for Sharon.

When I was in Pine Flat, I met several kids who appeared in the film and portraits, some we encountered on the road and some we visited in their homes. We stopped by one family's house to deliver some portraits Sharon had recently printed. The dad was cooking at the stove while Sharon laid out the portraits on the dining room table, and all four kids seemed a bit too busy with their various activities to fuss too much about what they looked like in the pictures. Some of them had already received their portraits. During the tour of their newly renovated house, I noticed one of the boys had tacked his portrait over his very cluttered, and obviously very utilized, computer desk. I fought hard to suppress the instinct to pull out my camera and take a picture.

Eventually my sister had to return from the middle of nowhere to the suburbs, when the father of her baby was jailed for something like armed robbery of a pharmacy. When I finally called her back, she told me that her now grown-up baby recently got out of jail and upon his release was slapped with an $8,000 jail bill, which of course he can't pay, and that he's thinking of moving to Canada to avoid the fallout of not paying up. Also, because he has developed an allergy to what the doctors suspect to be fast-food hamburger meat, and this allergy causes him to go into anaphylactic shock, which is deadly, he's been visiting the emergency room a lot, and those bills are piling up too. It seems he's dreaming his escape out of the penal system and into socialized

medicine. Socialized medicine, or anything vaguely akin to it, is a worn-down, hopeless cause of the liberal left, and this depiction of my sister's kid is exactly why conservatives hate the idea of it.

This poster child for impoverished American youth is quite literally the poster child for Sharon's very first film, *Khalil, Shaun, A Woman Under the Influence*, which she made while we were in graduate school together. At that time I believe Shaun's father was still in jail, meaning my sister was a single mother with many hardships, and Shaun was not doing well in school, or doing well in general. While his mom was around he was a pill, a pain, and as soon as she left him to Sharon, he wasn't. Their film and photo shoot, which involved a complex application of theatrical makeup, lasted several days, a lot of which I witnessed. Sharon's casting of Shaun offered me a privileged glimpse into her engagement with her "subject," expanding some notion that I already had about the way she made art, which I could never quite articulate without sounding trite. All I could say was there was something motherly about what she was doing, and this was before a mother figure featured prominently in her first film.

In *A Woman Under the Influence*, director John Cassavetes and actress Gena Rowlands collaborated to bring forth a mother character who is at once perfectly tender and loving and at risk of being utterly incompetent. In a scene taken straight from that film, Sharon portrays Shaun, disfigured by disease, being tenderly mothered. I saw Shaun transform momentarily into a different kind of kid when he was working with Sharon, and frankly I don't know exactly what he's transformed into in the intervening twelve or so years. I guess you could say I'm not a very good aunt. Over the years, Sharon has sent him books or other publications in which his picture appears. She's been attempting to come to terms with the distance between the child frozen in the photograph and the adult he is becoming today.

My nieces and nephews think I'm sort of famous because they sometimes see that I made it into books or magazines, but that's about as far as my role modelling goes. Sharon, on the other hand, has this quality of using her fame—by which I suppose I really just mean her success—in ways that make kids feel like *they* should be famous, not in any delusional way about becoming stars, but in a grounded and

positive way. She simply transmits to them the most positive aspects of fame: self-confidence and independence. I want to tell you to think of Andy Warhol's screen tests, but I figured I'd leave that sort of thing out, though a reference to another artist and filmmaker, Larry Clark, is unavoidable at this point.

There's a town down the mountain from Pine Flat. This town, Visalia, a suburb of Bakersfield, was ostensibly the inspiration for and the setting of Larry Clark's relatively recent film *Ken Park*. The film is extreme, in that it explicitly depicts every Jerry Springer violation known to teens and their parents. It opens with an unforgettably disturbing scene of a kid racing toward his own suicide, which he proceeds to commit in broad daylight in front of his own video camera, in a skate park crowded with his peers. Sharon told me that when she was watching the film, there was a scene in which she thought she recognized one of the kids from her own movie. Maybe the kid in question had left the mountain to be with another parent, or maybe he had gone away to a special school after getting kicked out of the regular one, or maybe there was no reason at all for her to think one of her kids would be sharing bong hits and sad stories with other boys in front of Larry Clark's camera. She said she was convinced it was him and had to rewatch the scene many times before she realized, with some sense of relief I suppose, she was mistaken. It is this double take, this impossibly unfavorable crossover between two worlds seemingly so far from each other that moved me to write what you just read the way that I did.

Frances Stark is an artist and writer based in Los Angeles. Her book, *Frances Stark: Collected Writing 1993–2003*, was published in 2003 (London: Book Works).

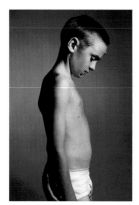

Shaun, 1993 (detail)
5 framed chromogenic prints
14 x 10 inches each

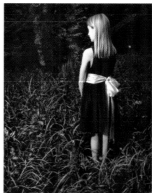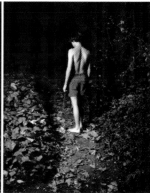

Julia Thomas, 1994
2 framed chromogenic prints
49 x 61 inches each

Biography

Born
Norwood, Massachusetts, 1964

Education
1993 Art Center College of Design, Pasadena, M.F.A.
1991 San Francisco Art Institute, San Francisco, B.F.A.

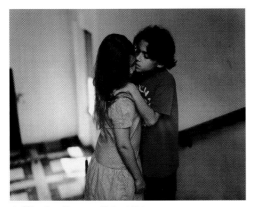

Audition One: Simone and Max, 1994
From the series *Auditions*
Framed chromogenic print
49 x 61 inches

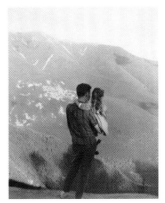

Untitled Study
(re-photographed snapshot #1), 1994
Framed chromogenic print
15 ½ x 13 ½ inches

139 One-Person Exhibitions

2005
Pine Flat, Sala Rekalde, Bilbao (cat.)
Gío Marconi, Milan

2004
Gallery Tomio Koyama, Tokyo
neugerriemschneider, Berlin

2003
Blum & Poe, Los Angeles
Barbara Gladstone Gallery, New York

2001
Sharon Lockhart, Museum of Contemporary Art, Chicago; Museum of
 Contemporary Art, San Diego (cat.)
Sharon Lockhart: Interview Locations / Family Photographs, Blum & Poe,
 Santa Monica

2000
MAK Center for Art and Architecture, Vienna
Barbara Gladstone Gallery, New York
Wako Works of Art, Tokyo

1999
Sharon Lockhart: Teatro Amazonas, Museum Boijmans van Beuningen,
 Rotterdam; Kunsthalle Zürich; Kunstmuseum Wolfsburg (cat.)
*Maria da Conceição Pereira de Souza with the Fruits of the Island of
 Apeú-Salvador, Pará, Brazil*, Pitti Immagine Discovery, Florence
Galerie Mot & Van den Boogaard, Brussels
neugerriemschneider, Berlin

1998
Sharon Lockhart, The Kemper Museum of Contemporary Art and
 Design, Kansas City
Goshogaoka Girls Basketball Team, Galerie Yvon Lambert, Paris
Goshogaoka Girls Basketball Team, Friedrich Petzel Gallery, New York;
 Blum & Poe, Santa Monica; Wako Works of Art, Tokyo (cat.)

1997
S.L. Simpson Gallery, Toronto

1996
Blum & Poe, Santa Monica
Friedrich Petzel Gallery, New York
neugerriemschneider, Berlin

1995
Sharon Lockhart, Künstlerhaus Stüttgart

1994
Friedrich Petzel Gallery, New York
Auditions, neugerriemschneider, Berlin

1993
Shaun, Art Center College of Design, Pasadena

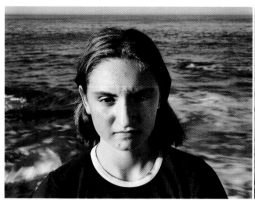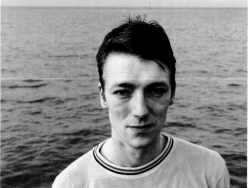

Lily (approximately 8am, Pacific Ocean), Jochen (approximately 8pm, North Sea), 1994
2 framed chromogenic prints
31 x 41 inches each

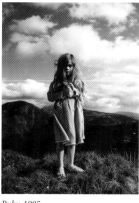

Ruby, 1995
Framed chromogenic print
66 ⅛ x 49 inches

Selected Group Exhibitions

2005
En attente, Casino Luxembourg, Luxembourg (cat.)
Bidibidobidiboo, Fondazione Sandretto Re Rebaudengo, Turin (cat.)
Shadowland: An Exhibition as a Film, Walker Art Center, Minneapolis (cat.)
An Aside, Camden Arts Centre, London; The Fruitmarket Gallery, Edinburgh; Glynn Vivian Art Gallery, Swansea (cat.)
Universal Experience: Art, Life, and the Tourist's Eye, Museum of Contemporary Art, Chicago; Hayward Gallery, London (cat.)

2004
2004 Biennial Exhibition, Whitney Museum of American Art, New York (cat.)
Made in Mexico, Institute of Contemporary Art, Boston; Hammer Museum, Los Angeles; Art Institute of Chicago (cat.)
Videodreams: Between the Cinematic and the Theatrical, Kunsthaus Graz
The Big Nothing, The Fabric Workshop and Museum, Philadelphia, and Institute of Contemporary Art, University of Pennsylvania, Philadelphia

2003
Cine casi cine 2003, Museo Nacional Centro de Arte Reina Sofía, Madrid (cat.)
Home and Away, Vancouver Art Gallery (cat.)
Fast Forward: Media Art: Sammlung Goetz, ZKM/Zentrum für Kunst und Medientechnologie (cat.)
10e Biennale de l'image en mouvement, Centre pour l'image contemporaine, Geneva (cat.)

2002
Photographier, Collection Lambert, Amsterdam (cat.)
Triennale der Photographie, Kunstverein, Hamburg (cat.)
9e Biennale de l'image en mouvement, Centre pour l'image contemporaine, Geneva (cat.)
exIT, Fondazione Sandretto Re Rebaudengo, Turin
Life Death Love Hate Pleasure Pain: Selected Works From the Museum of Contemporary Art, Chicago Collection, Museum of Contemporary Art, Chicago (cat.)

2001
Jasper Johns to Jeff Koons: Four Decades of Art From the Broad Collections, Los Angeles County Museum of Art; Corcoran Museum of Art, Washington, D.C.; Museum of Fine Arts, Boston; Guggenheim Museum, Bilbao (cat.)
Public Offerings, Museum of Contemporary Art, Los Angeles (cat.)
Made in California: Art, Image, and Identity, 1900–2000, Los Angeles County Museum of Art (cat.)
6e Biennale d'art contemporain de Lyon (cat.)
The Beauty of Intimacy: Lens and Paper, Gemeentemuseum, Den Haag, The Netherlands; Staatliche Kunsthalle Baden-Baden; Kunstraum, Innsbruck

2000
Beyond Boundaries: Contemporary Photography in California, California State University, Long Beach; Santa Barbara Contemporary Arts Forum, Santa Barbara; Ansel Adams Center for Photography, San Francisco (cat.)
Elysian Fields, Musée National d'Art Moderne, Centre Georges Pompidou, Paris (cat.)
Freeze, Espaço Cultural Sergio Port, Rio de Janeiro (cat.)
Quotidiana: Immagini della vita di ogni giorno nell'arte del XX secolo, Castello di Rivoli (cat.)
Interventions: New Art in Unconventional Spaces, Milwaukee Art Museum (cat.)
2000 Biennial Exhibition, Whitney Museum of American Art, New York (cat.)

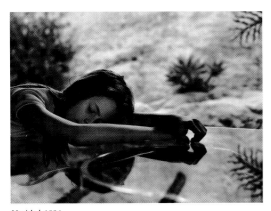

Untitled, 1996
Framed chromogenic print
32 x 43 inches

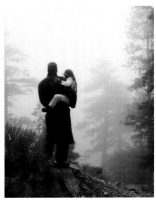

Untitled, 1996
Framed chromogenic print
61 ⅛ x 49 inches

1999
Moving Images: Film-Reflexionen in der Kunst, Galerie für
 Zeitgenössische Kunst, Leipzig (cat.)
Cinéma Cinéma: Contemporary Art and the Cinematic Experience,
 Stedelijk Van Abbe Museum, Eindhoven (cat.)
So Faraway, So Close, Encore Bruxelles, Brussels; Museum of Modern
 Art, Oxford (cat.)
Visions, Les Rencontres Internationales de la Photographie, Arles

1998
Choreography for the Camera, Walker Art Center, Minneapolis
Tell Me a Story: Narration in Contemporary Painting and Photography,
 Le magasin, Centre National d'Art Contemporain de Grenoble
 (cat.)
Fast Forward Archives, Kunstverein, Hamburg
Scratches on the surface of things, Museum Boijmans Van Beuningen,
 Rotterdam
Sightings: New Photographic Art, Institute of Contemporary Arts,
 London (cat.)

1997
Stills: Emerging Photography in the 1990s, Walker Art Center,
 Minneapolis
Truce: Echoes of Art in an Age of Endless Conclusions, SITE Santa Fe (cat.)
Scene of the Crime, Hammer Museum, Los Angeles (cat.)
1997 Biennial Exhibition, Whitney Museum of American Art,
 New York (cat.)

1996
Sharon Lockhart, Stan Douglas, Hiroshi Sugimoto, Museum Boijmans
 Van Beuningen Museum, Rotterdam
Playpen & Corpus Delirium, Kunsthalle Zürich
Hall of Mirrors: Art and Film Since 1945, Museum of Contemporary
 Art, Los Angeles; Wexner Center for the Arts, Ohio State
 University, Columbus; Palazzo delle Esposizoni, Rome; Museum
 of Contemporary Art, Chicago (cat.)
Persona, The Renaissance Society at the University of Chicago;
 Kunsthalle Basel (cat.)

1995
La belle et la bête: Un choix de jeunes artistes américains, Musée d'Art
 Moderne de la Ville de Paris (cat.)
Campo 95, Corderie dell'Arsenale, Venice; Fondazione Sandretto Re
 Rebaudengo per l'Arte, Torino; Konstmuseet, Malmö, Sweden (cat.)

1994
Nor Here Neither There, Los Angeles Contemporary Exhibitions
 (LACE) (cat.)

1993
Zuzueglich, Merz Academy, Stuttgart

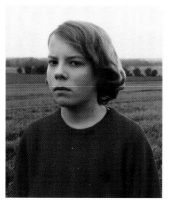

Portrait of a Boy, 1996
Framed chromogenic print
31 1/16 x 25 1/8 inches

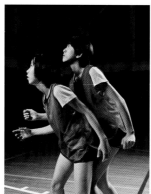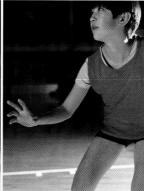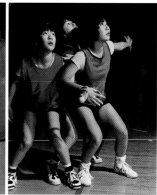

Goshogaoka Girls Basketball Team:
Kumi Nanjo and Marie Komuro, Rie Ouchi, Atsuko Shinkai, Eri Kobayashi and Naomi Hasegawa, 1997
3 framed chromogenic prints
32 5/16 x 27 3/8 inches each

Selected Film Screenings

Pine Flat (2005)
REDCAT, Los Angeles (2006)
Berlin International Film Festival (2006)
Sundance Film Festival, Park City (2006)
Bilbao Fine Arts Museum (2006)

NŌ (2003)
Museu da Imagem e do Som, São Paulo (2004)
Forum of New Cinema Berlin (2004)
Rio de Janeiro Film Festival (2004)
International Film Festival Rotterdam (2004)
Hong Kong International Film Festival (2004)
Berlin International Film Festival (2003)
Toronto Film Festival (2003)

Teatro Amazonas (1999)
Tate Modern, London (2002)
Anthology Film Archives, New York (2001)
Los Angeles County Museum of Art (2001)
Rio de Janeiro International Film Festival (2001)
Telluride International Experimental Cinema Exposition,
 Denver (2000)
Margaret Mead Film and Video Festival, Pacific Film Archive,
 University of California, Berkeley (2000)
New York Film Festival (2000)
International Film Festival, Berlin (2000)
Museum Boijmans van Beuningen, Rotterdam (1999)
Museum Ludwig, Cologne (1999)

Goshogoaka (1998)
Film Society of Lincoln Center, New York (2006)
Walker Art Center, Minneapolis (2005)
Pacific Film Archive, University of California, Berkeley (2003)
Kunsthalle Kiel (2003)
Tate Modern, London (2002)
Los Angeles County Museum of Art (2001)
Rio de Janeiro International Film Festival (2001)
Stedelijk Van Abbemuseum, Eindhoven (1999)
New Directors, New Films, The Museum of Modern Art and the Film
 Society of Lincoln Center, New York (1998)
Sundance Film Festival, Park City (1998)
Institute of Contemporary Arts, London (1998)
Moderna Museet, Stockholm (1998)

Khalil, Shaun, A Woman Under the Influence (1994)
Museo Nacional Centro de Arte Reina Sofía, Madrid (2003)
Vienna International Film Festival (2000)
Institute of Contemporary Arts, London (1998)
Moderna Museet, Stockholm (1998)
Vancouver Film Festival (1997)
Museum of Contemporary Art, Los Angeles (1996)
Los Angeles Contemporary Exhibitions (1996)
The Screening Room, Friedrich Petzel Gallery, New York (1994)

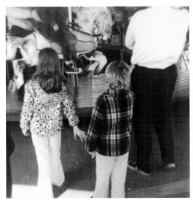

Untitled Study
(re-photographed snapshot #10), 1999
Framed chromogenic print
15 ½ x 13 ½ inches

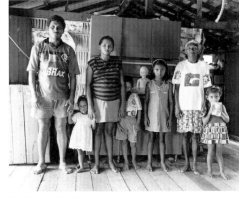

The Monteiro Family
Manoel Nazareno Souza Monteiro, Valciria Ferreira Monteiro,
Maria da Conceição Ferreira Monteiro, Alex Nazareno Ferreira
Monteiro, Valquiria Ferreira Monteiro, Margarida Ferreira Costa,
Laudicéia Ferreira Monteiro
Apeú-Salvador, Pará, Brazil
Survey of Kinship Relations in a Fishing Community
Anthropologist: Isabel Soares de Souza, 1999 (detail)
3 framed gelatin silver prints
27 x 32 ½ inches each

143 Selected Bibliography

Books

MacDonald, Scott. *A Critical Cinema 5: Interviews With Independent Filmmakers*, 311–32. Berkeley: University of California Press, 2006.

Sharon Lockhart. Chicago: Museum of Contemporary Art and Ostfildern: Hatje Cantz, 2001. Essays by Dominic Molon and Norman Bryson.

Sharon Lockhart. Tokyo: Wako Works of Art and Santa Monica: Blum & Poe, 1998. Essay by Bérénice Reynaud.

Sharon Lockhart: Pine Flat. Bilbao: Sala Rekalde, 2006. Exh. cat. Texts by Mark Godfrey, Inés Katzenstein, Chus Martínez, Ignacio Vidal-Folch, and Catherine Wood.

Sharon Lockhart: Teatro Amazonas. Exh. cat. Rotterdam: Museum Boijmans Van Beuningen and NAi Publishers, 1999. Essays by Timothy Martin and Yvonne Margulies.

Articles

Altstatt, Rosanne. "Sharon Lockhart im Gesprach mit Roseanne Altstatt." *Neue bildende Kunst*, no. 4 (June–July 1999): 36–41.

Aukeman, Anastasia. "Sharon Lockhart." *Art in America* 83, no. 4 (April 1995): 112.

Baker, George. "Photography's Expanded Field." *October*, no. 114 (Fall 2005): 132–40.

Baker, George, et al. "Round Table: The Projected Image in Contemporary Art." *October*, no. 104 (Spring 2003): 71–96.

Bryson, Norman. "From Form to Flux." *Parachute*, no. 103 (July–September 2001): 86–107.

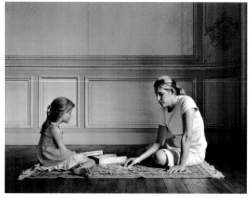

Maja and Elodie, 2003 (detail)
2 chromogenic prints
49 x 65⅛ inches each

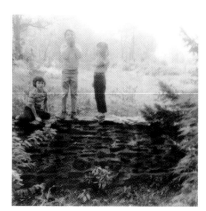

Untitled Study
(re-photographed snapshot #12), 2004
Framed chromogenic print
15½ x 13½ inches

Bryson, Norman. "Sharon Lockhart: The Politics of Attention." *Artext*, no. 70 (August–October 2000): 54–61.

Brooks, Rosetta. "A Fine Disregard." *Afterall*, no. 8 (2003): 107–13.

Calame, Ingrid. "Sharon Lockhart at Blum & Poe." *LA Weekly*, March 13–18, 1998: 57.

Dziewior, Yilmaz. "Sharon Lockhart: Concept, Structure, and Passion." *Camera Austria*, no. 72 (2000): 25–36.

Dziewior, Yilmaz, and Sharon Lockhart. "A Thousand Words: Sharon Lockhart Talks About *Teatro Amazonas*." *Artforum* 38, no. 6 (February 2000): 104–05.

Farmer, John Alan. "Sharon Lockhart: Interview Locations/Family Photographs." *Art Journal* 59, no. 1 (Spring 2000): 64–73.

Greenstein, M. A. "Sharon Lockhart." *Art Issues*, no. 43 (Summer 1996): 37.

Kaplan, Cheryl. "Sharon Lockhart: Barbara Gladstone Gallery." *Tema Celeste*, no. 83 (January–February 2001): 91.

Hainley, Bruce. "Shooting Hoops." *Artforum* 36, no. 9 (May 1998): 19.

Harvey, Dennis. "*Goshogaoka*." *Variety*, February 9–15, 1998: 74.

Holden, Stephen. "Tokyo Girls Play It Safe." *New York Times*, March 28, 1998: A20.

Holte, Michael Ned. "The Observer." *Frieze*, no. 95 (November–December 2005): 99–103.

Hunt, Ian. "Sharon Lockhart: Museum Boijmans Van Beuningen, Rotterdam." *Frieze*, no. 52 (May 2000): 107–08.

Joisten, Bernard. "Sharon Lockhart: Interview With Bernard Joisten." *Purple*, no. 2 (Winter 1998): 328–35.

Koehler, Robert. "Pine Flat." *Variety*, February 13–19, 2006: 66.

Martínez, Chus. "The Possible's Slow Fuse: The Works of Sharon Lockhart." *Afterall*, no. 8 (2003): 115–22.

McDonald, Daniel. "Sharon Lockhart." *Frieze* (January–February 1995): 63–64.

Miles, Christopher. "Sharon Lockhart." *Art/Text*, no. 62 (August–October 1998): 88–89.

Pagel, David. "Big Questions in the Tiny Details." *Los Angeles Times*, October 24, 2003: E29.

Pagel, David. "Lockhart's Polished Photos Invite Reverie." *Los Angeles Times*, March 14, 1996: F10, 12.

Pagel, David. "Photographer Lockhart Puts Her Still-Lifes Into Motion." *Los Angeles Times*, June 14, 2001: 53, 56.

Pedrosa, Adriano. "Sharon Lockhart: *Teatro Amazonas*." *Trans*, no. 7 (2000): 59–62.

Pokorny, Sydney. "Sharon Lockhart." *Artforum* 35, no. 8 (April 1997): 92.

"Questionnaire: Sharon Lockhart." *Frieze*, no. 92 (June/July/August 2005): 174.

Relyea, Lane. "Openings: Sharon Lockhart." *Artforum* 33, no. 3 (November 1994): 80–81.

Saltz, Jerry. "Sharon Lockhart." *Time Out New York*, November 28–December 5, 1996: 46.

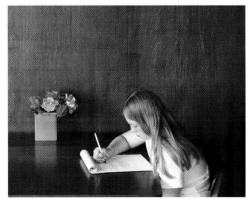

Untitled, 2004
Framed chromogenic print
36 x 45 ½ inches

145 Schwendener, Martha. "Sharon Lockhart: Exotic Structures." *Flash Art* 34, no. 220 (October 2001): 84–87.

Smith, Roberta. "Sharon Lockhart: Friedrich Petzel Gallery." *New York Times*, March 20, 1998: B35.

Stjernstedt, Mats, "Omtagninagar: Sharon Lockharts arbeiten med film/Retakes: Sharon Lockhart's Work in Film." *Paletten* 57, no. 1 (1996): 31–36.

Tumlir, Jan. "Sharon Lockhart." *Artforum* 42, no. 5 (January 2004): 159–60.

von Osten, Marion. "Es lauft alles nach Plan [Everything Goes According to Plan]." *Texte zur Kunst* 10, no. 39 (September 2000): 189–96.

List of Plates

Pine Flat Portrait Studio, 2005
19 framed chromogenic prints
45 ½ x 35 ¾ inches each

> *Jessie, Breanna, Kassie, Chance*
> *Becky, Damien, Katie*
> *Dakota*
> *Maleah, Travis*
> *Sarah, Sarah, Mikey*
> *Mikey, Sierra*
> *Matthew, Matthew*
> *Sierra*
> *Ryan*

Pine Flat, 2005
16mm color/sound film, 138 minutes

Untitled (Boy with guitar), 2005
Framed chromogenic print
49 x 62 inches

Untitled, 2005
Framed chromogenic print
41 x 51 inches

Untitled, 2005
Framed chromogenic print
41 x 51 inches

Untitled, 2005
Framed chromogenic print
41 x 51 inches

All works courtesy Blum & Poe, Los Angeles;
Barbara Gladstone Gallery, New York; and
neugerriemschneider, Berlin.

Acknowledgments

147 I thank all of my friends in Pine Flat for their trust, friendship, and commitment to this project over the last three years: Amy Bates, Jessica Blain, Matthew Blain, Sarah Blain, Jessica Carrabello, Chance Caviness, Ashley Cornejo, Ryan Cowan, Dimitri Derrick, Blake Derrington, Dylan Eubanks, Balam Garcia, Breanna Gifford, Jessie Goldman, Travis Goldman, Kody Harrell, Maleah Harrell, Seth Kirkpatrick, Becky Mueller, Katie Mueller, Mikey Reed, Dakota Sandborg, Ethan Sandborg, Garett Sandborg, Kassie Sandborg, Molly Smith, Junior Snider, Kevin Snider, Jessica Tracy, T.J. Weatherly, Alex Wilbur, Damien Wilbur, and Sierra Zimmerman.

I am exceptionally grateful to Kathy Halbreich, for her continual support, including her essay for this publication; to the curators, Pedro Lapa, Linda Norden, who also contributed an essay to this publication, and Joan Rothfuss; to Frances Stark, for her text; and to Frank Escher, John Alan Farmer, Ravi GuneWardena, and Conny Purtill.

I thank the following individuals, who gave me so much support while making this project: Becky Allen, Lisa Anne Auerbach, Rosalie Benitez, James Benning, Tim Blum, Kate Brown, Charong Chow, Shannon Ebner, Douglas Fogle, Robert Gardner, Barbara Gladstone, Charles Gute, Thomas Hall, Joanne Heyler, Bruce Jenkins, Clay Lerner, Giuseppe Liverani, Jean Lockhart, Tim Martin, Chus Martínez, Jeremy Marusek, Zadka Mikelsen, Tim Neuger, Adam Ottavi-Schiesl, Jeff Poe, Burkhard Riemschneider, Russell Roberts, Walter Rose, Florian Seedorf, Studio P Inc., Lucien Taylor, Yasmil Ventura, Phillippe Vergne, Erika Vogt, and Cindy and Gary Wilbur. I also thank Alex Slade for his love and unwavering support.

Finally, special thanks to the parents and community members of Pine Flat, who contributed so generously to this project.

To find out more about Charta, and to learn
about our most recent publications, visit

www.chartaartbooks.it

Printed in April 2006
by Leva spa, Sesto San Giovanni
for Edizioni Charta